London
UNDERGROUND

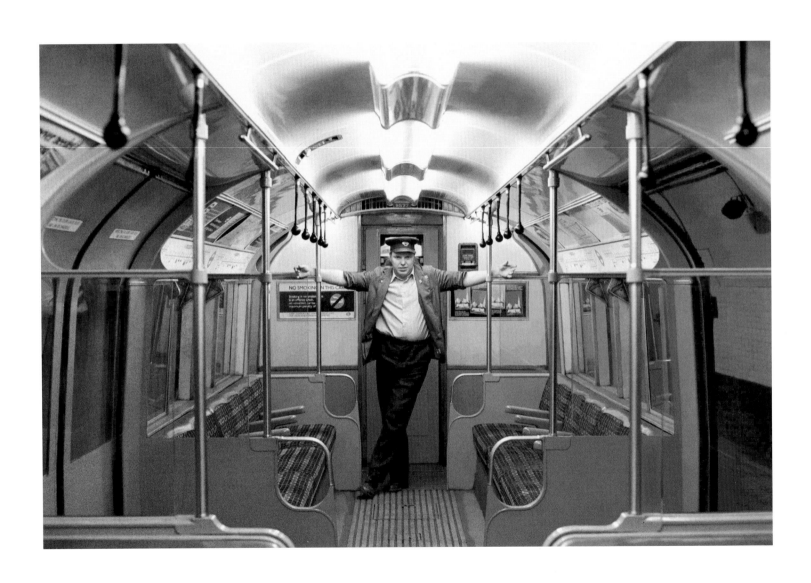

London
UNDERGROUND

ARCHITECTURE, DESIGN AND HISTORY

DAVID LONG
PHOTOGRAPHY JANE MAGARIGAL

The History Press

Other books on London by David Long:

Spectacular Vernacular: London's 100 Most Extraordinary Buildings

Tunnels, Towers And Temples: London's 100 Strangest Places

The Little Book of London

The Little Book of the London Underground

When Did Big Ben First Bong? 101 questions answered about the greatest city on Earth

Hidden City: The Secret Alleys, Courts and Yards of London's Square Mile

First published 2011

The History Press
The Mill, Brimscombe Port
Stroud, Gloucestershire, GL5 2QG
www.thehistorypress.co.uk

© words, David Long, 2011
© photographs, Jane Magarigal, 2011

The right of David Long to be identified as the Author
of this work has been asserted in accordance with the
Copyrights, Designs and Patents Act 1988.

British Library Cataloguing in Publication Data.
A catalogue record for this book is available from the British
Library.

ISBN 978 0 7524 5812 0

Typesetting and origination by The History Press
Printed in Malta
Manufacturing managed by Jellyfish Print Solutions Ltd

CONTENTS

INTRODUCTION

A Lincolnshire-born lawyer, the son of a draper, and by most accounts a cold, austere, teetotal Quaker whom even those close to him described as lacking most social graces, Frank Pick (1878–1941) is an unlikely hero for the twenty-first century. Yet the fact remains that 100 years after his appointment as Commercial Manager of the Underground Electric Railways Company of London it can fairly be said that almost everything good about the modern London Underground network can in some proximate fashion be traced back to Pick, his cerebral approach to problem solving, his diligent, detail-obsessed character and a pioneering personal philosophy.

This in itself is not news. During his lifetime Pick famously refused both a knighthood and a peerage, and it is now more than three decades since a major London museum marked the centenary of his birth with a rich and well-attended exhibition devoted to his quite exceptional achievements. It is significant too that in celebrating

London Underground – architecture, design and history

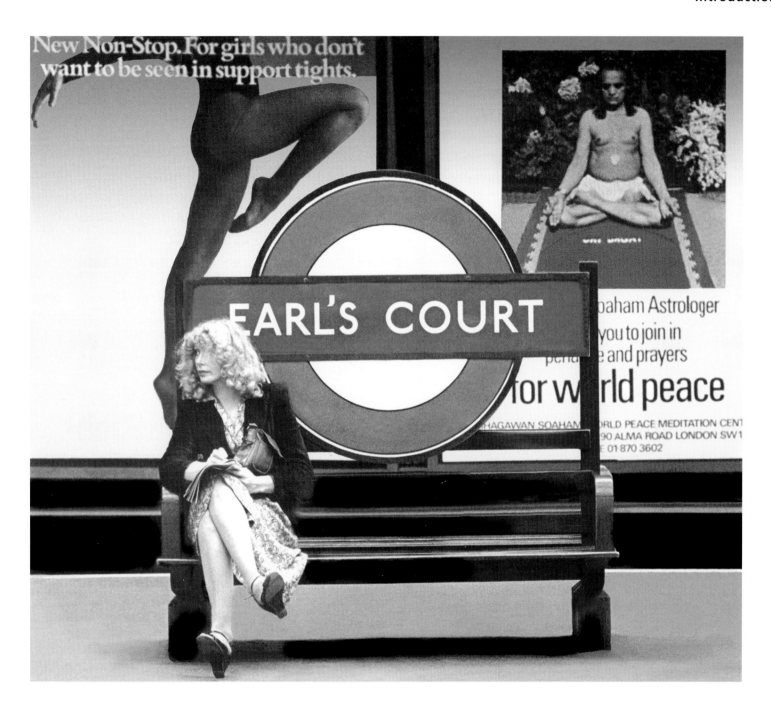

the all-encompassing nature of Frank Pick's wide-ranging contribution to the administration of the capital's transport system from 1908 to 1940, the V&A's superb retrospective – *Teaspoons to Trains* – chose for the first time to honour the head of a commercial entity in this fashion.

Today, even so, the reality is that those same achievements are largely taken for granted by the vast majority of Tube users; also that Frank Pick's name can scarcely be said to be of national or even regional renown, even though within his own spheres of transport and design the brilliance of his leadership and example still resonates down the years.

Instead, when it comes to fare-paying passengers on the Underground, a degree of familiarity and sometimes even of contempt is the most likely explanation for why most of us simply fail to notice our surroundings – that is, unless and until something goes wrong on one of the approximately one billion journeys made each year along its more than 250 miles of electrified track.

At the same time the idea of a world class organisation having a coherent marketing strategy, and using consistent design standards to promote and unify its myriad services, is now so well established that it is easy to overlook just how genuinely revolutionary were Pick's theories about branding and presentation in those early days. Pick was, however, one of the true pioneers of this approach, and indeed of the very idea of corporate design and branding, and this despite his complete lack of training or experience in any of the relevant disciplines.

His successful rebranding of the Underground found one of its earliest flowerings in a series of posters promoting the hitherto dowdy and conservative commuter services running in and out of central London. From the start Pick was determined that his team should understand that every single element of what in time was to become London Transport needed to be devised, designed and maintained to the highest

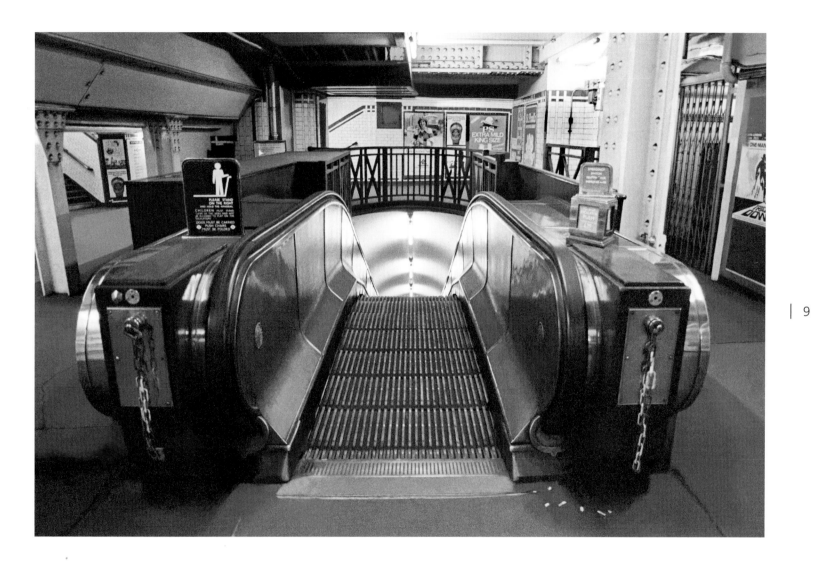

possible standards – and everything we know now effectively flowed from that one, overwhelming certainty.

Personally convinced, as Pick put it, that 'a high standard of design in all things is essential to lasting prestige and therefore to the smooth running of a great public service,' his vision was soon to encompass far more than just the creation and display of more effective, more memorable – and in the best examples genuinely iconic – promotional posters. New station architecture, the design of bus stops, seat fabrics and platform furniture, the creation of a new, bespoke typeface to be employed in every individual piece of corporate communications and station signage, the world famous London Transport roundel, and of course Harry Beck's celebrated Underground map – everything, even now, can be traced in a straight, unbroken line back to the desk of Frank Pick.

It is true that subsequent bouts of restoration, refurbishment and remodelling at both platform and street level have on occasion served to obscure much of the work that so many fine architects, designers and artists undertook at Pick's behest. But many of the essentials are still there if one cares to look for them: the clean, clear signage; the internationally recognised roundel – which is still very much a logo for London, and as recognised internationally as the Olympic rings; Beck's magnificent map; and of course the Tube's uniquely rich architectural heritage which is shown to such outstanding effect in the pages of this book.

Originally recruited as a functionary in the quiet, boring backwater of the traffic statistics office, Pick's strong work ethic and painstaking attention to detail could have produced an efficient if dull administrator. Instead by the time of his death in 1941, recognised for his quick mind and exceptional ability to grasp operational technicalities, he was being hailed as a genius by many and lauded by the architectural historian Nikolaus Pevsner as 'the greatest patron of the arts whom this century has so far produced in England, and indeed the ideal patron of our age.'

With the war against Hitler to worry about, Winston Churchill may on a personal level have been entirely happy to see the back of someone he dismissed as an 'impeccable busman', following Pick's brief and unhappy secondment to the Ministry of Information. But only a very few years later, and with favourable comparisons being made to Lorenzo the Magnificent (the greatest of all Medicis), Kenneth Clark, at that time Director of the National Gallery, suggested that 'in another age he might have been a sort of Thomas Aquinas.'

Today, 100 years after he first stepped up to the challenge, it is quite impossible to conceive a public sector administrator being likened to an authentic cultural behemoth such as Lorenzo il Magnifico, still less a revered thirteenth-century philosopher-saint. Instead one can only repeat feebly how fortunate it is that Frank Pick's rich and uniquely practical artistic legacy has survived as well as it has and belongs to London and to its people.

1 ➤→

ARCHITECTURE I
Arts & Crafts

P rior to Pick's arrival what was to become the world's first subterranean railway network had mostly been driven beneath the city's streets by a number of powerful vested interests, their business dealings often highly questionable and involving an unsavoury cast of speculators, unscrupulous foreigners and financiers with little interest in anything beyond personal prestige and monetary gain.

It is true that in 1845, when Charles Pearson, Solicitor to the City of London, first proposed alleviating traffic congestion by running trains underground, his vision had been an intelligent and enlightened one. Describing 'a majestic eight-track covered way, thoroughly lighted and ventilated', Pearson's influential pamphlet on the subject envisioned a wonderful sounding 'Arcade Railway'. This was to carry more than 250,000 commuters a day into and around London through shallow tunnels with the motive power coming from so-called 'rope of air' technology.

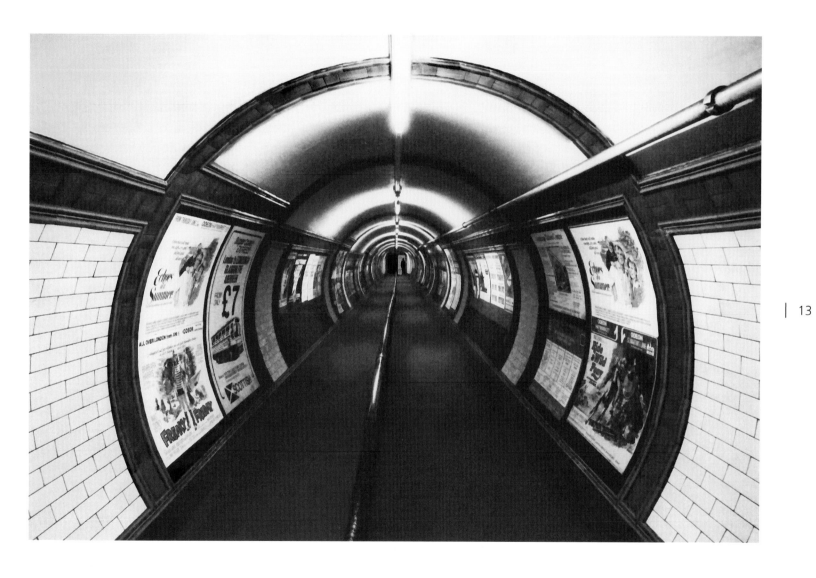

(If that failed to measure up – as indeed, like every other pneumatic railway, it did – Pearson favoured a similarly flawed system of windlassed cables with fixed engines at either end.)

But instead, while fiery protesters such as the Smithfield preacher Dr Cuming continued to rail against a scheme in which the end of the world was to be 'hastened by the construction of underground railways burrowing into the infernal regions and disturbing the devil,' the rampant commercial free-for-all which followed hard on the heels of the Pearson initiative meant that the first practical underground railway was from the start badly fragmented, frequently filthy and malodorous for travellers, and more often than not highly inefficient when in operation.

For all that, by the start of the twentieth century, there were certainly sufficient lines, trains and services to warrant the use of the term 'network'. Unfortunately at this time the lines, many of which we would recognise today albeit under other names, were conceived, excavated, owned and operated by half a dozen separate commercial entities. Far from cooperating – for example by providing connecting services and combined ticketing, or by linking up to form the logical and much-needed Circle Line – their proprietors seemed mostly to be at war with each other.

In almost every way, what London had was a long way from Pearson's ideal; nor was it even close to becoming the sort of streamlined, integrated transport network which a city as large and globally pre-eminent as London clearly and urgently required. In 1904, after fleeing his creditors, one of the aforementioned financiers found himself at the Royal Courts of Justice where he took his own life after being convicted of numerous cases of fraud. (Although carrying a cocked and loaded revolver into the court, James Whitaker Wright opted to leave it quietly, courtesy of a capsule containing potassium cyanide.) A year later another one died less violently but equally suddenly, leaving behind a golden bedstead said to have belonged to the King of the

Belgians and a chaotic legacy of debt and disorder. He was the infamous American, Charles Tyson Yerkes, whose rule of business had been simply to 'buy up old junk, fix it up a little and unload it upon other fellows.'

The chaos bequeathed by such chancers and scam artists, and by a number of other speculators with more ambition than understanding of how the railways worked, had at least pointed the way towards further consolidation. Once these individuals were off the scene moves were soon afoot to accelerate a critically needed process of unification. This was something which had already started beneath the umbrella of the American's Underground Electric Railways Company, but it clearly needed to progress further.

As part of an urgently needed, more unified approach to marketing these diverse services, the term 'Underground' had been adopted back in 1908 by all of London's competing underground railways although already many train users preferred an even simpler term: the Tube. Within another year Frank Pick was appointed to the post of Traffic Development Officer, joining the growing Underground Group from the provincial North Eastern Railways and quickly beginning his rapid rise to the top as the organisation expanded.

In 1912, for example, the Underground Group had acquired the Anglo-French London General Omnibus Company. Founded back in 1855 as Le Compagnie Generale des Omnibus de Londres, the organisation had retired its last horse-drawn service only the year before and succeeded in establishing a commanding monopoly position across London as a bus operator and builder offering services which could in theory integrate well with the trains. Logic similarly suggested the Underground Group should make moves to absorb the traditionally loss-making trams of the splendidly named British Electric Traction, so that by the 1920s a gradually consolidating entity was beginning to morph into something which we would recognise today.

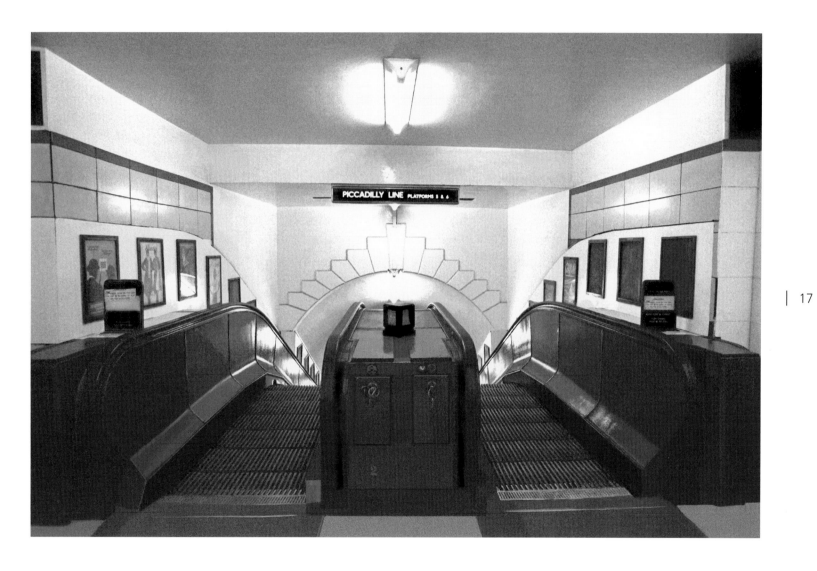

The similarity to our own Transport for London looked even more marked once moves were afoot to nationalise the various different companies. In 1929 a new Labour government had shown itself to be implacably opposed to what had become in effect a series of privately owned monopolies; and increasingly even political moderates were beginning to suspect that competition had achieved all it was likely to in terms of improving the capital's hugely complex and varied transport systems.

The first decisive move came with the passing in 1933 of the landmark London Passenger Transport Act, creating an entirely new organisation called London Transport. It was by any measure a large and potentially unwieldy beast. Badly fragmented and hugely diversified, Frank Pick recognised immediately that its successful operation would require enormous thought and administrative efforts if it was to function as the sort of efficient, integrated and above all unified network its backers had envisaged.

Prior to this there had been some slight foreshadowing of what was to come when the aforementioned Yerkes had taken on the young London- and Paris-trained architect Leslie William Green (1875–1908). Green's brief was to design a number of new stations for three of the company's new lines: the Great Northern, Piccadilly & Brompton Railway; the Baker Street & Waterloo Railway; and the Charing Cross, Euston & Hampstead Railway. In time, with power provided by Yerkes' own electrical in-house generation station at Lots Road in Chelsea these were to develop into the present day Piccadilly, Bakerloo and Northern lines.

The energetically maverick Yerkes was keen to establish a coherent design theme for his new lines and stations, and as an expressly hands-on employer he always had very clear ideas about how he wanted his various projects to be taken forward. His technical expertise in this and other areas may have been slight to non-existent, but as a firm believer in the superiority of American means and methods he was determined to find a way to impose a consistent look and feel across all his stations. These, he said, needed to be bold, distinctive and, most importantly, 'fully equal to those of the best stations on the Central London Railway.' Fortunately the precise details of how this was to be achieved he left to his new architect.

18

Above ground, Green, just twenty-nine years old at this time, favoured a strong, uniform Arts and Crafts style, cleverly adapting a single coherent and flexible design to suit some fifty or so individual sites on the aforementioned lines.

With each one characterised by broadly similar façades of traditionally manufactured, ox-blood faïence or tin-glazed terracotta blocks – 'Burmantoft's Faïence' produced by the long-established Leeds Fireclay Company – the stations themselves nevertheless employed a new and highly advanced means of construction. Behind the positively Victorian tilework were strong, easy-to-assemble, structural steel frames of a type which had only recently arrived from the United States.

For Green the ox-blood exteriors made for buildings which would be instantly recognisable as Tube stations in even the most crowded streetscapes. They would thus be highly visible, but not so outlandish as to compromise their quiet suburban or more historic neighbours, and he was to use the material on all but five of his stations. At the same time the steel frames made possible the large, uninterrupted internal spaces which were needed for ticket halls and lift shafts.

Externally the buildings were further distinguished by their façades' wide bays and by large and striking semi-circular windows at first-floor level. Located beneath a heavily dentilated cornice these same windows concealed the machinery for the lifts down to platform level.

Doubtless to his employer's delight, Green's inspired choice of a steel skeleton made his new stations very quick to build and so comparatively cheap for (what were mostly) two-storey buildings in an urban environment. The faïence was an economical choice too – costing as little as 9s per square foot, with very low maintenance – as well as being durable and quick to produce. From Green's point of view another important benefit was that the terracotta could be readily formed into the different shapes and decorative mouldings he wished to incorporate into individual station designs.

20

Finally, constructed with rentable space for shops at street level, Leslie Green's stations were designed with flat roofs in order to encourage the construction of commercial office development above, another not inconsequential benefit of that robust, steel load-bearing frame. Leasing or selling off the sites for commercial development in this way was to be an important method for Yerkes and his inheritors to raise capital for further expansion of their railway, although a number of outlying stations such as Kilburn and Chalk Farm (which incidentally has the longest of Green's stylish façades) have so far not been built over.

Inside, Leslie Green's stations were similarly designed in order to conform to a basic universal pattern, although with specific detail changes routinely made as he moved from one station to another. Most employed the same, highly durable floors of concrete and crushed granite, and had lustrous bottle-green tiling reaching up the walls to a shoulder height dado of acanthus leaves or pomegranate beneath plain cream tiles. Wishing to convey an honest sense of craftsmanship, robustness and almost imperial quality, Green also had new station lifts, fixtures and fittings made in carved wood and smart brass clocks to hang in each ticket hall. (Equipped with a self-winding mechanism, these cost the not inconsiderable sum of £4 apiece.)

Thereafter detail variations might include discreet decorative touches such as the floral Art Nouveau-influenced flourishes at Knightsbridge (now gone, sadly) and cartouches between the windows at South Kensington. Elsewhere other small adjustments were made to the tiling around ticket windows and the stations' trademark 'Way Out' signs. For example Chalk Farm station acquired a Palladian window, while the Cranbourn Street frontage to Leicester Square station incorporated a pair of cricket bats and some wickets after J. Wisden & Company, publisher of the famous yellow sporting almanacs, took steps to lease the offices above.

At platform level Green's influence was perhaps less obvious than that of his American chairman, although he favoured a more standardised tiling design, incorporating the station's name together with clearly identifiable individual colour schemes (for the

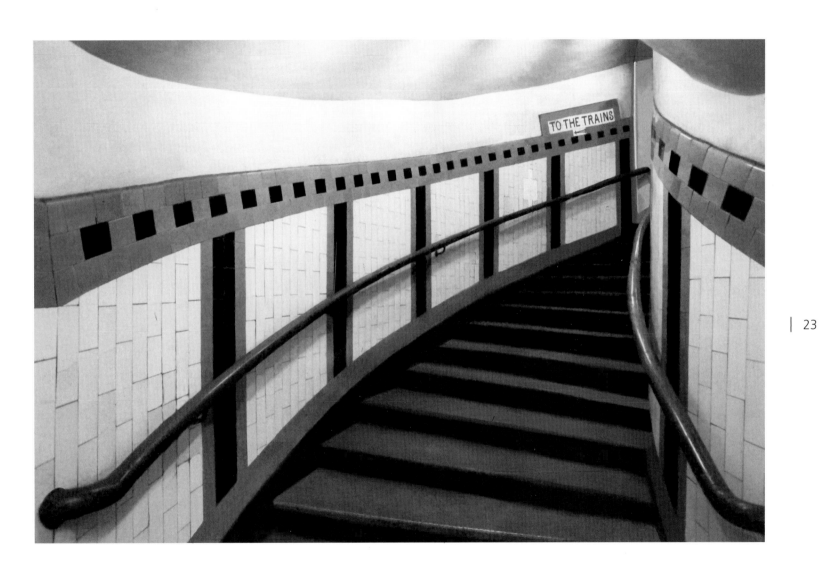

different lines) and recurring geometric tile patterns along the length of the platforms. The installation of the vast majority of this tiling was entrusted to the company of W.B. Simpson & Sons, a firm which happily is still in business after more than 175 years.

With three lines to complete, a final cost of £100,000 and an eventual tally of around two million tiles – equivalent, if this helps, to ten Greenwich Foot Tunnels – it was at the time the largest commission of its type anywhere in the world. Unfortunately, not much of that same tilework can now be seen by normal Tube users, although a quantity of it survives in varying states of repair behind advertising hoardings and other, later accretions. Sporadic attempts have been made to rescue some sections, and railway enthusiasts keenly note the location of marker tiles such as the one at Covent Garden showing the tile manufacturer –'Sole Apptd. Agent Maw & Co.' – and the installer. These signature markers were often to be found in the lower stair and lift landing areas.

Above ground Green's work has perhaps fared slightly better. It is true that some of his station buildings are no longer used for their original purpose; under the aegis of Pizza on the Park the entrance and ticket hall at Hyde Park Corner once hosted the likes of George Melly, Scott Hamilton, Marlene VerPlanck, Claire Martin, Barbara Cook, Digby Fairweather and John Dankworth, and the Dover Street premises are partly given over to a travel agency. But even here the distinctive façades are still there to be seen, a fortunate outcome since – disgracefully – relatively few of these landmarks have been afforded the necessary protection of an official listing.

It is important that they should be, however. By the time of his death – in 1908, his demise at just thirty-three definitely hastened by overwork – Green's prodigious output had provided the strongest possible argument in favour of good, coherent industrial design. In accepting this inheritance, Frank Pick and his team were very soon dramatically to exceed anything attempted under the eye of Charles Tyson Yerkes. But completing fifty stations in just five years Leslie William Green, something of an unsung hero, certainly deserves recognition for combining form and function in a way which a century on still has the authority to command our attention.

24

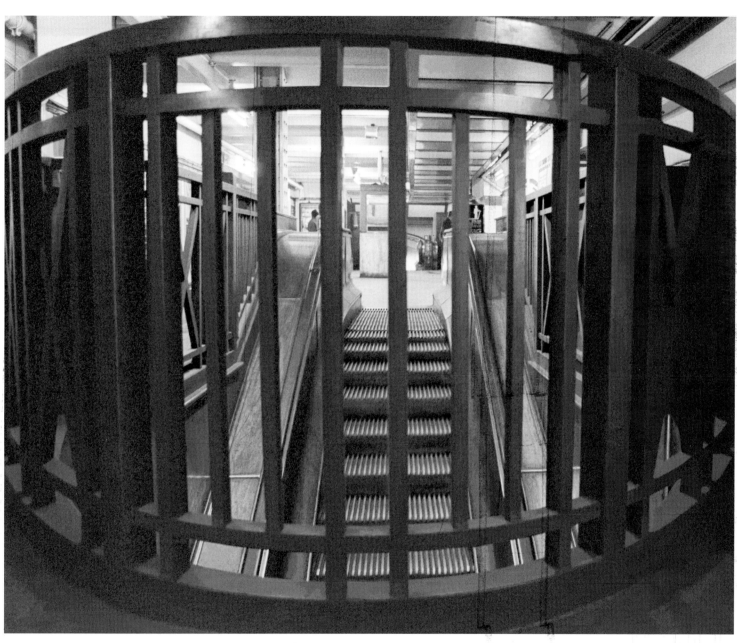

2 ➤→

UNDERGROUND TO ANYWHERE
Keeping Up the Numbers

Throughout his long career in transportation Pick always insisted that his well advertised commitment to art and good design was simply that of an administrator, a salesman even, looking for an efficient way to boost passenger numbers. Arriving in London he had been quick to realise that the key to increasing ticket sales lay in persuading Londoners to use the Tube during their leisure hours. It had to be, he said, since no one could reasonably be expected to travel into the centre of London and out again more than once during the course of his normal working day.

Faced with a similar problem at his old company, North Eastern, his employers had introduced a considered policy of using promotional posters to encourage weekend and holiday travel. In London, and finding himself in charge of publicity, Pick rapidly sought to do likewise, endeavouring to boost passenger numbers by demonstrating to the travelling public the perfect utility of the network when it came to pleasure as well as business.

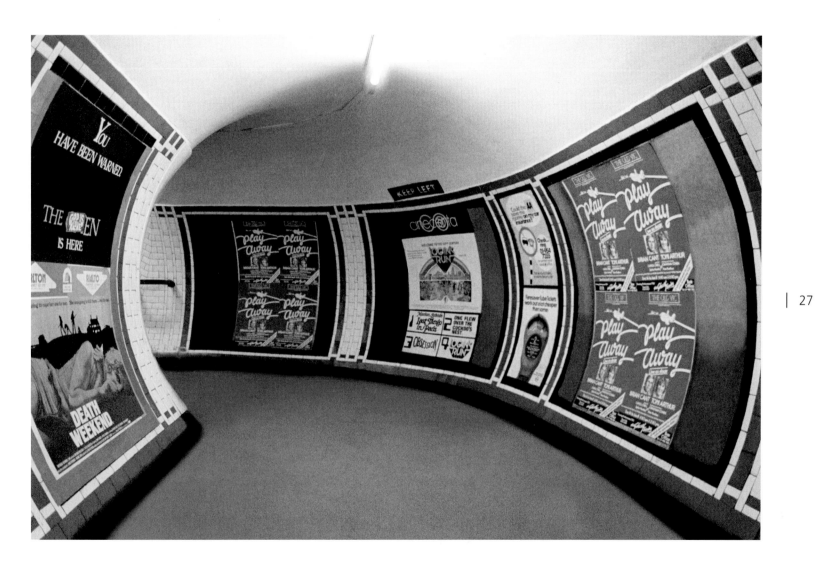

At the same time Pick fully realised that the Underground Group – and he with it – had inherited a terrible, almost unworkable jumble of different branches and stations which was in need of rapid overhaul and massive remedial action. As a pragmatist he identified at once the need to create a more coherent system, one which was easy to use, easier to comprehend, and more pleasant to travel on. But, perhaps even more significantly, Frank Pick the idealist recognised that what was to become the London Underground also had the makings to be far more than just a transport network. Most obviously it could serve to unify the huge, diversified and extended conurbation that Edwardian London had become, bringing a sense of order to the city just as Napoleon III's Haussmann Plan had done for Paris. Pick furthermore saw the network's potential as a genuine civilising agent, sincerely believing that the population of London could be uplifted and have their lives improved through the influence of the contemporary arts and good design.

This was something he stressed in a speech given to a meeting of the Royal Society of Arts in 1935.'Underneath all the commercial activities of the Board,' he insisted, 'underneath all its engineering and operation, there is the revelation and realisation of something which is in the nature of a work of art . . . It is, in fact, a conception of a metropolis as a centre of life, of civilisation, more intense, more eager, more vitalising than has ever so far been obtained.'

In his bid to remodel his new domain along these lines, to recast it as the world's most progressive public transport system, the posters were clearly never going to be anything but a starting point – and never one to do anything in a half-hearted manner, Pick himself certainly hit the ground running. A volume of ticket sales was of course already guaranteed: tens of thousands of Londoners had no choice but to use the Tube to get to and from work. As he saw it, Pick's task was to persuade them to use it for recreation as well, for day trips to the zoo or weekend jaunts to museums and suburban historic houses, to outlying beauty spots and city centre parks, cinemas, shops and theatres.

28

Advertising posters of varying quality already filled the walls of many underground stations: in the early days of the Tube one correspondent to *The Times*' letters pages had mentioned the desirability of being able to one day alight from a train 'without having to hunt through all the soap, pills, whisky, milk &tc. to find the name of the station.' To combat this chaos Pick took the decision to bring in a measure of control, reserving a proportion of the advertising sites for in-house promotion, and employing freelance commercial artists to fill these spaces with bold and colourful images designed to alert travellers to attractions which could conveniently be reached by underground train.

His masterstroke – and again, to modern ears this sounds like a statement of the obvious – was quickly to appreciate that the posters' visibility and effectiveness would be maximised if each was designed using the same, strong, standardised graphic language. Also that his message would be markedly more compelling and less confusing for passengers hurrying to home or office if these in-house posters were always positioned in particular, more prominent parts of the station.

30 |

'After many fumbling experiments,' he recalled with typical modesty many years later, 'I arrived at some notion of how poster advertising ought to be. Everyone seemed quite pleased and I got a reputation that really sprang out of nothing.' As part of that notion the organisation's own posters and maps soon began to appear in illuminated boards at station entrances; advertisements for other, paying concerns were now relegated to special sites on platforms and in passages to further distance them from Pick's 'official' promotions.

In spite of his lack of artistic training, or possibly because of this, Pick's ambitions for his poster-led advertising strategy quickly grew. No longer content to allow the printing firms he had under contract to recommend or employ their own anonymous commercial artists to undertake what he saw as this important work, Pick started to commission them himself.

31

Against a background of widespread professional scepticism – before the First World War many businesses were still to be persuaded by the notion that poster advertising could show even a modest return – Pick was proud of his posters and determined to keep the quality high. To do this he selected both emerging and established artists and did so to such good effect that an invitation to submit an idea to the Underground Group soon became a keenly sought mark of prestige for any visual artist.

For all his talk about merely pushing ticket sales, Pick had very high social ideals as well, and genuinely saw part of his role as a public educator. To further this cause he organised a number of exhibitions in the ticket hall at Charing Cross Underground station, keen to highlight the value as he saw it of contemporary art and design. It was a lofty ambition, but in a sense there was no need: the best of the work was already on display every day in literally scores of Underground stations, and as Nikolaus Pevsner was later to observe, 'no exhibition of modern painting, no lecturing, no school teaching can have anything like so wide an influence on the educationable masses as the unceasing production and display of London Underground posters over the years.'

John Hassall's now celebrated 'No Need to Ask a P'liceman' was the first of these to be commissioned by Pick, and the first to appear with the soon widely recognised UNDERGROUND branding with its superscale bookend letters. Delivering his client's all-important message – Underground to Anywhere: Quickest Way, Cheapest Fare – Hassall's gouache image was eye-catching, bright, catchy, inclusive and like his famous 'Skegness is So Bracing', wittily drawn, particularly so by Edwardian standards. Sensibly it also relied far more heavily on illustration than on text, unlike most commercial posters up to this point.

Not unnaturally Pick's earliest commissions went to established artists such as Hassall – who at one point was producing eight new designs a week – and later to the likes of Graham Sutherland, Fred Taylor, Paul Nash, László Moholy-Nagy and Frank Brangwyn.

Throughout his career he worked hard to persuade artists of standing to work for him, including perhaps most famously Man Ray, the American-born, Paris-based surrealist. The strangely ethereal 'Keeps London Going', Man Ray's night-sky juxtaposition of Saturn with the London Transport roundel, is among the more beautiful and most enigmatic images of the 1930s. At the same time Man Ray's claim to 'have always preferred inspiration to information' is one which Pick himself would have instinctively warmed to and understood.

However, Pick is also now remembered as a patron of new, young artists, and with good reason. Having identified the rare talents of another American, Edward McKnight Kauffer, as early as 1915, Pick was instrumental in his going on to become one of the twentieth century's most prolific and influential graphic artists. (Also the man, in the words of Paul Nash, 'responsible above anyone else for the change in attitude towards commercial art in this country.')

Fluent in the visual languages of Cubism, Futurism, Vorticism and Surrealism, Kauffer went on to work for numerous public and private sector bodies during his forty-year career. But it is in the more than 140 posters produced during his twenty-five years with the Underground that he was best able to demonstrate his outstanding abilities to translate the recondite and often highly complex idioms of the avant-garde into a form which was accessible to the ordinary traveller. Indeed for many Londoners the posters commissioned by Pick would have been their first introduction to the often bewildering, fast-moving storm of conflicting 'isms' which characterised the art world during inter-war period.

Many of the posters, it is true, can appear to more modern eyes as almost comically utopian. Some were used to promote now quite absurdly aspirational views of a suburban existence, most obviously perhaps as it was played out in the immense ribbon development of 'Metro-land' which sprang up either side of the Metropolitan Railway.

On other stretches there was Victor Hembrow's suggestion that, 'It's a change you need – move to Osterley', and indeed the promotion of pastoral 'Golders Green: a place of delightful prospects'.

Similarly, viewed from the distance of nearly 100 years, it is now all too easy to ridicule the notion that anyone might seek to spend a day in the bucolic surroundings of Teddington Lock, depicted in all its sub-Constable splendour by H.M. Wilson in 1912. Or indeed to wonder if it really is true that someone, somewhere devised a poster in 1939, telling would be travellers, 'Don't worry about the Germans invading the country, do it yourself by Underground'.

Putting modern cynicism aside, however, Pick was definitely on to something. Prior to his intervention such publicity material as the Tube produced was hopelessly text-heavy and more often than not far too complicated to effectively convey a message. But it was also becoming clear that his new posters were going to be just the start.

3 ➤━━➤

MAN OF LETTERS
Edward Johnston

Described as a design dictator, and not always in an entirely complimentary manner, it now seems unsurprising that someone as high-minded, needle-sharp in his observations and visually literate as Pick would eventually seek to clarify his message by influencing the choice and variety of lettering on the Underground. Not just when it came to the various artists responsible for his popular and successful posters either, but throughout the entire Underground system.

With something similar in mind the late Herbert Spencer, designer and editor of the journal *Typographica*, once drove his car from Marble Arch to Heathrow Airport. As he observed and recorded the myriad different road signs he passed along the way, he discovered, 'a jumbled jungle of words in a vast range of styles . . . a remarkable demonstration of literary and graphic inventiveness in a field where discipline and restraint would be both more appropriate and considerably less dangerous.'

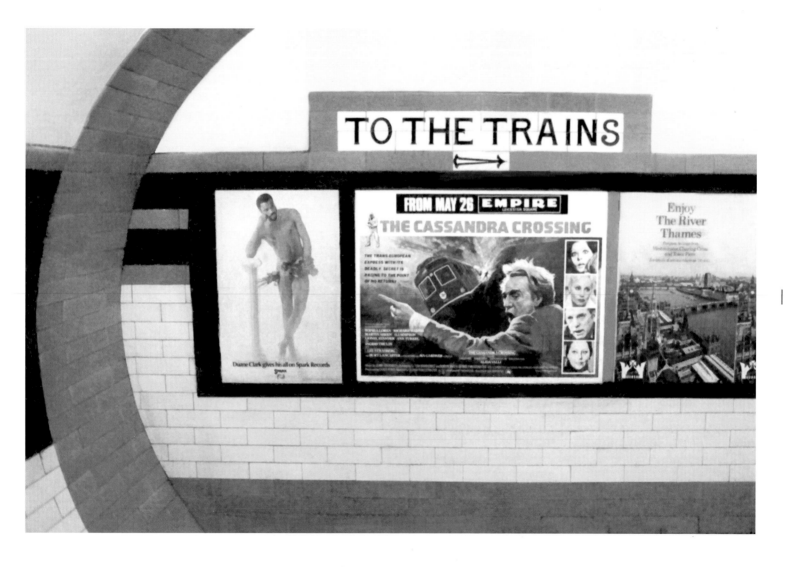

But that was not until 1961: Pick had reached the same conclusion almost half a century earlier, albeit only in his own realm, deep underground. Unlike Herbert Spencer, however, as well as identifying a problem he had the authority and commercial clout to do something about it. Never in doubt as to the power of clear communication, he set himself the task of banishing from the Underground its own equivalent of those hopeless old road signs, unplanned anachronisms which in the words of an editorial in *The Times* 'faintly resembled a hat stand and pointed vague, lofty fingers down leafy lanes.'

In 1908, after some argument, the various independently owned companies which operated the different lines had as previously noted agreed to adopt the term Underground in all their promotional and publicity material. The familiar, larger capital 'U' and 'D' at either end were eventually accepted too, which helped translate the word into a sort of proto-logo, more eye-catching than descriptive, although the different companies tended to undermine its power by using a senseless variety of typefaces, corporate brands and public information signs.

Pick felt strongly that the place to start was with the first of these and through his office the task of devising a more appropriate typeface – strong enough to be used across all UERL services – fell to Edward Johnston (1872–1944).

Regarded absolutely as the father of British calligraphy – and sharing international honours in the field with his Nuremburg-born contemporary Rudolf Koch – the largely self-taught Johnston is credited with almost single-handedly reviving the art in this country. A failed medic (due to ill health) he did this through both teaching, at W.R. Lethaby's Central School of Arts and Crafts and the Royal College of Art, and by practice at an artistic community he established at his home beneath Ditchling Beacon in Sussex.

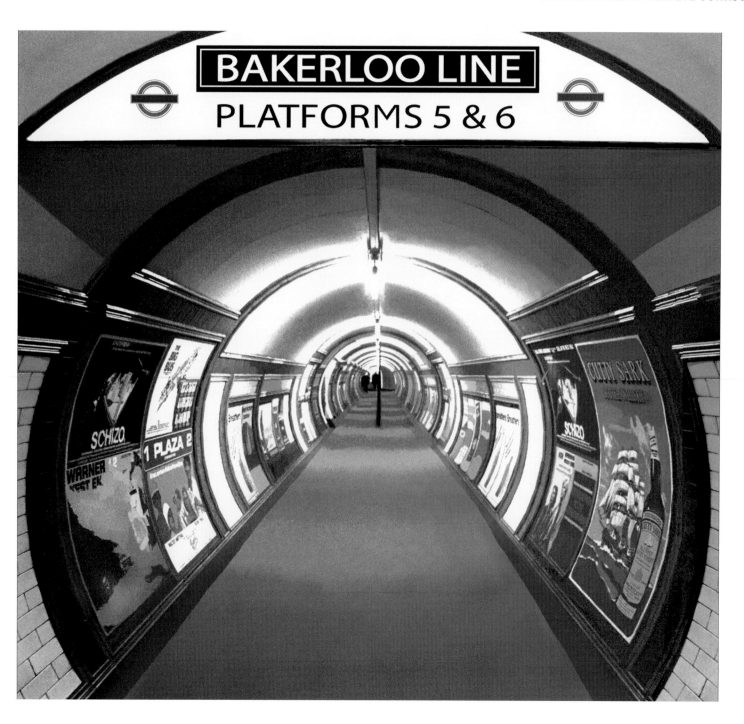

His writing was also hugely influential, in particular through the publication in 1906 of *Writing and Illuminating and Lettering* which has remained in print ever since. Though its author was personally fairly reclusive, the book's impact was sufficiently far-reaching that within just four years of its publication Sir William Rothenstein was able to observe on a visit to several leading art schools on the continent that, 'in Germany in particular the name of Edward Johnston was known and honoured above that of any artist.'

More recently Hermann Zapf, the leading exponent of contemporary typeface design, has said of him, 'Nobody had such a lasting effect on the revival of contemporary writing as Edward Johnston. He paved the way for all lettering artists of the twentieth century and ultimately they owe their success to him.' (Following his death in 1944 the *Dictionary of National Biography* was equally generous, advancing the suggestion that 'to the practice of a single craft he probably brought as much genius as any craftsman who ever lived.')

Johnston had first been approached by Pick back in 1913 and commissioned to develop a brand new typeface specifically for use by London Underground. In particular, identifying a standardised typeface as a key component of his more wide-ranging plan to strengthen the organisation's corporate identity, Pick asked Johnston to devise a font with 'the bold simplicity of the authentic lettering of the finest periods' but which nevertheless gave the firm impression of 'belonging unmistakably to the twentieth century.'

The result was the world's first humanist sans-serif font. Devised to make a clean break with what was then the ubiquitous school of overweight, heavy-handed and sometimes tortured Victorian 'grotesque' typefaces, it was bold, modern and above all clear. Its parentage was clear too, and for many years it was officially known as Underground Railway Block (or simply just Underground) and subsequently as Johnston's Railway Type.

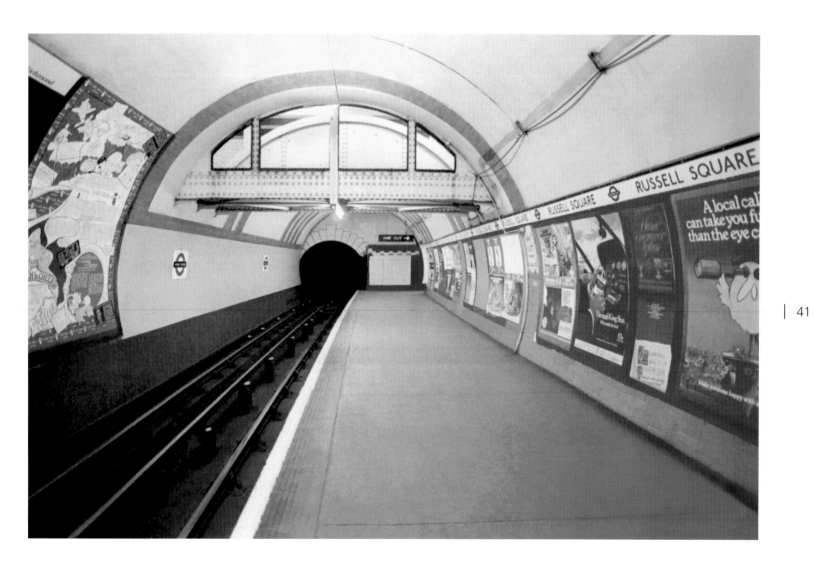

Inspired by Classical letter forms, Johnston's brilliant creation used capitals based on Roman square lettering, and lower case figures reportedly based on fifteenth-century Italian handwriting. Now more commonly known as Johnston Sans, it was further distinguished by its perfectly round 'O' and a capital 'M' which very satisfyingly forms an exact square with the diagonal strokes meeting at its centre. It is also known for the use of diamond-shaped dots or tittles above the 'i' and 'j' and for full stops. (Commas, apostrophes and other punctuation marks are also based on this same, neat stylistic device.)

As both men had hoped, the use of plain block letters of this type, unfussy Roman proportions based on regular geometric shapes, and main strokes of equal thickness, proved to be perfect when it came to optimising legibility for passengers viewing the new signs across crowded platforms and station concourses, or when walking briskly by.

For many, sans-serif fonts of this kind had slightly unwelcome continental associations, particularly with such alien, avant garde cultural organisations as the Bauhaus in Germany. But after the first version was launched in 1916 (Johnston continued to work away at it until 1931) the new lettering quickly found its way onto official station signs and posters throughout the network. Today it is widely acknowledged to be a genuine design classic, and one which could not sit better with the slightly minimalist, machine-age aesthetic of the Tube.

Otherwise its exceptional quality is perhaps best vouchsafed by the longevity and extraordinary versatility of Johnston's original concept. Nearly a century later a variation of it is still in use by Transport for London, although happily it is Johnston's original which can be enjoyed in the images reproduced here as Eiichi Kono's clever but subtle modifications to produce 'New Johnston' were not finally to be introduced until the early 1980s.

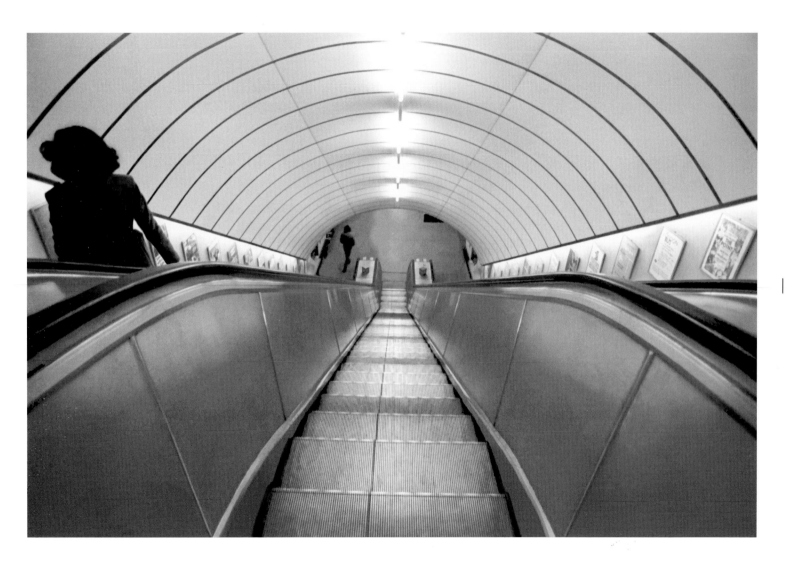

43

Equally impressively, on Pick's watch, as the Underground Group gradually morphed into the larger, more complex London Transport, the use of the new font spread far beyond the Underground. Finding its way on to buses, trams, even bus-stops, eventually it started appearing on lorries as well following the nationalisation of Britain's road haulage industry in 1948 to form British Road Services. (Somewhat curiously British Rail elected to use something quite different for its own services, however. Even so that company's decision to adapt the old LNER's Gill Sans lettering was nevertheless to provide a strong Johnstonian link. Its creator, the celebrated if controversial sculptor Eric Gill, had been a pupil of Johnston's and during his time with the master had worked with him on the Underground commission.)

Finally, and as if to underline Frank Pick's credentials as a lawyer and businessman rather than an artist or designer, it is interesting to note that London Transport was from the first very careful to restrict the use of its new font. Today the organisation's inheritors at Transport for London exercise a similar degree of control, being keen to stress on their website that TfL 'owns design and copyrights for all cuts of the New Johnston font'. And as well they might, given its status as a model of typographical clarity and simplicity, not to mention its very considerable impact and continuing influence around the world.

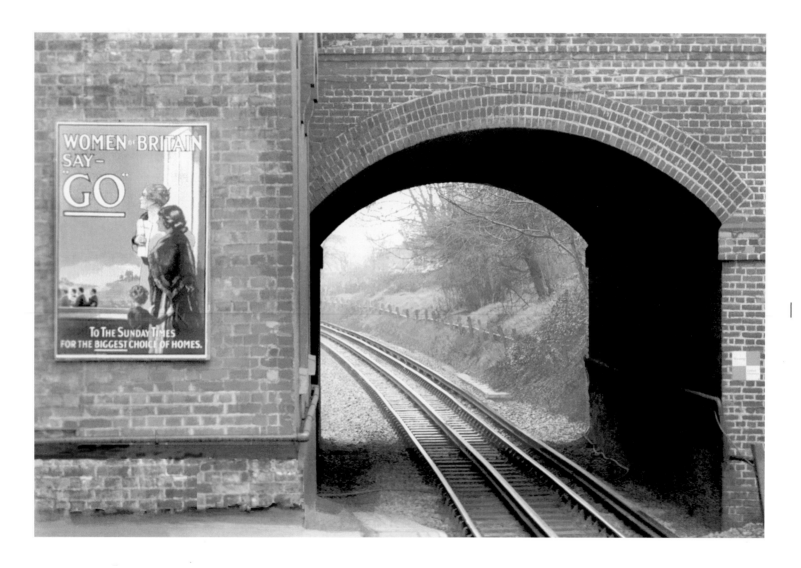

4 ➤➤

THE ROUNDEL
A Logo for London

While Johnston is best remembered for his work on the alphabet he was also intimately involved with the refinement of a new bar and circle logo for the Tube – the world famous target or 'roundel' which is sometimes referred to as the twenty-seventh letter of that same alphabet.

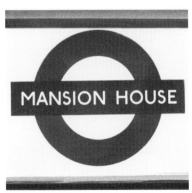

Every bit as emblematic of London as Tower Bridge, a Routemaster bus or black cab, a Beefeater or that more recent icon, Ken Shuttleworth's Gherkin, the famous symbol sprang originally from neither Pick nor Edward Johnston. Though demonstrably one of the first, best, most familiar and most enduring corporate logos, it was derived from an older and visually more complex design which had been registered as a trademark by the aforementioned London General Omnibus Company.

This was in 1905, incidentally, some years before the latter was brought into the Underground Group. Intended to represent a 'winged wheel' with a bar across it,

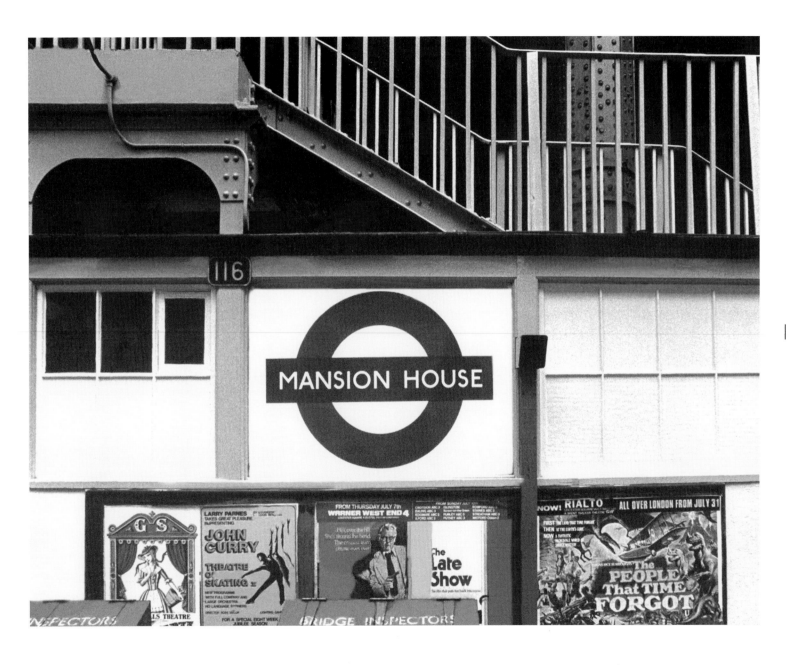

the horizontal bearing the word GENERAL, the logo was cleverly adapted for the Underground Group and almost certainly at Pick's behest. While documentary evidence for this is yet to be uncovered, he is known to have admired the YMCA logo – which is broadly similar, with a bar bisecting an inverted triangle – and certainly recognised both it and the bus company's version as good examples of the art, if not quite good enough for him.

Pick initially favoured a solid red disc for the Tube, with a blue bar across its equator, a design which in appearance avoided the slight fussiness of the LGOC's more archaic-looking wheel device. The word GENERAL was also to be replaced by the logotype UNDERGROUND which as previously noted was slowly becoming more familiar to regular users of the Tube.

Introduced to stations in 1908, in the form of this solid red enamel disc with a horizontal blue bar framed in timber mouldings, this early design was rapidly adopted for use as station name boards. Intended to give prominence to the name of the station and help those passengers hoping to alight to distinguish it from surrounding commercial advertising, an unexpected vote of confidence in the new design surfaced in mid-1914 when the rival Metropolitan Railway introduced its own version, also red and blue but with a diamond in place of the circle.

Pick was far from finished with the roundel, however. Having already retained the services of Johnston to create a new font, he asked the designer to take a look at the roundel and to come up with ideas for something similar but better. By 1917 the latter had done so, the proportions of the roundel having been reworked to suit his new Railway Type lettering and to more neatly incorporate the UNDERGROUND logotype. The solid red disc had also become a lighter, circular frame with two D-shaped voids and, once pronounced good by Pick, the new symbol was soon registered as a protected trademark.

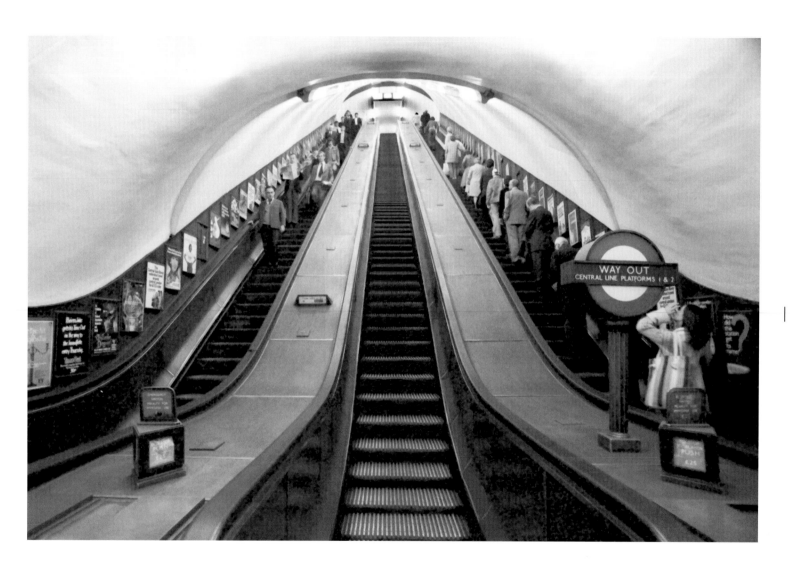

London Underground – architecture, design and history

Initially used on posters and other promotional material, by the early 1920s this latest version was soon being installed in growing numbers of stations at both street and platform level. To maintain the purity of his design Johnston drew up precise guidelines for the bulls-eye (as he continued to refer to it), minutely adjusting the balance and proportions of the various components to incorporate his standardised corporate typeface.

In fact he continued to tweak his design in this way for many years – as indeed he did with his now increasingly ubiquitous font – and many of those artists commissioned by Pick through the 1920s and '30s were similarly encouraged to incorporate elements of the new logo into their work. Typical was the aforementioned planet design by Man Ray; other posters saw the roundel wittily recast as wheels on a heavily stylised bus – albeit nothing like the LGOC's version – a UFO, and even the head of a commuter speeding by.

50 |

Geometrically a very simple form using striking colours, like the very best corporate logos around the world it has since proved seemingly to be infinitely adaptable. As a result, after more than 100 years, it is now to be found on buses, taxis, trams and even river buses as well as the Tube and Docklands Light Railway – although not without subtle but important adjustments being made to Johnston's original along the way.

The first of these followed Charles Holden's arrival in 1923 as the network's favoured architect, a move which saw the roundel's wholesale adoption as a more architectural component. Supported on Venetian masts outside stations, on immense brick towers or blown up to an enormous size and reproduced in stained glass set into clerestory windows above station entrances, the roundel's use on many of Holden's designs dramatically improved the profile of outlying stations making them even easier to locate on increasingly busy city streets and arterial roads.

Later, in 1935, following the creation and enlargement of London Transport, Hans Schleger was asked to revisit the roundel again as part of his project to design a new standardised bus stop. With the acquisition by the Underground Group two decades earlier of LGOC, and the multiplicity of other General, Tramways and Green Line services, growing passenger numbers meant it was no longer sensible to allow for public service vehicles to stop wherever and whenever a passenger hailed one or rang the bell.

Schleger's solution was to pare the design down still further, producing a dramatically simplified roundel consisting of a plain bar and circle in silhouette form. This cleverly retained the colour coding of the relevant services, and as such provided the basis for the bus stop signs which are still in use today. (Also, it might be argued, for the additional colour coding subsequently introduced to differentiate between the proliferating underground, overground, road, rail, dial-a-ride and river services.)

As noted previously Pick, while himself not possessed of a sense of humour, was content for leading artists such as Man Ray to play around with his precious roundel. Long after his death, in 1965, a version was even used to promote a pop programme on German television (admittedly one showcasing British talent). But generally speaking Pick's successors have shown themselves to be far more concerned with protecting the roundel's legal status than with allowing anyone to have fun with it or to tamper with its design.

Its unauthorised use has nevertheless been widespread, however, so that TfL's own sometimes questionable range of 'official' products – roundel-branded knickers, anyone? – is these days dwarfed by a veritable torrent of independent rip-offs. Besides scores of unofficial souvenirs, roundel copies of varying quality have appeared on everything from book jackets (to my mind the most witty application being the cover of Marilyn M. Lowery's *Mad Pursuit*) through toyshops and language schools to at least one adult cinema on Hamburg's notorious Reeperbahn.

But occasionally TfL relaxes its grip, as for example in 2008 when the organisation chose to celebrate the roundel's 100th year by asking 100 artists, British and foreign, to submit new works based on the world famous symbol. The pieces, by the likes of Jim Isserman, Alicia Framis, Henrik Hakansson, James Ireland and Sir Peter Blake, were subsequently exhibited to acclaim at Shoreditch. Thereafter two prints of each were produced, one for inclusion in the London Underground permanent collection and the other – signed and numbered – to be auctioned with a percentage of the proceeds going to the CLIC Sargent cancer charity.

Always so much more than a circle with a line through it, like the Tube itself the roundel just keeps on going.

5 ➤

MAPPING THE NETWORK
The Genius of Mr Beck

More famous even than the roundel, and after three quarters of a century entirely familiar to millions around the world who have yet even to set foot on an English train, is Harry Beck's famous map of the London Underground. A match for Johnston's font in terms of its outstanding legibility, and an object lesson in intelligibility and durability, the map also stands as perhaps the finest single example of design introduced during the Pick era. At the same time the story of its creation and gradual evolution provides the perfect parallel to the struggle in which Pick and others were engaged while working to create a single, unified and integrated underground transport network.

For decades, as we have seen, individual lines ran independently of each other, with different operators, fare structures and timetables. Yet a city the size and complexity of London clearly required something better. This meant having a network which was readily intelligible to its users and – to enable them to get the most from it –

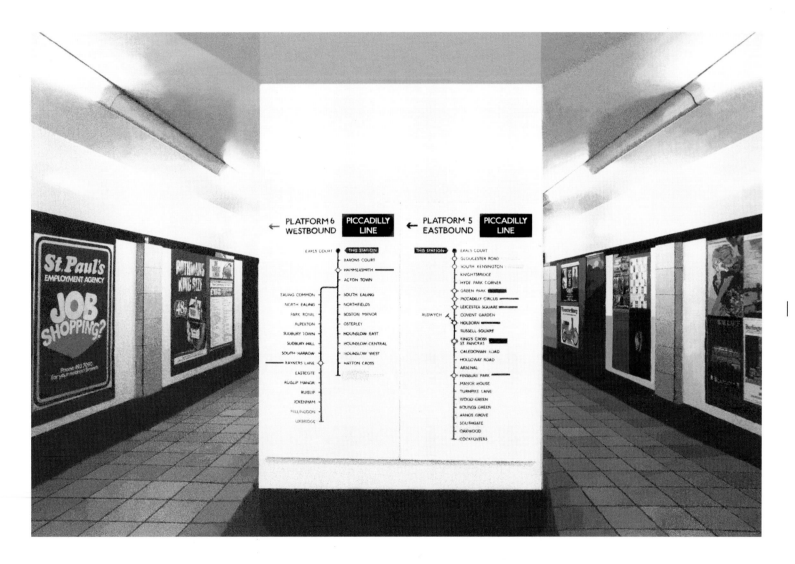

an inclusive transport map depicting the whole of it rather than just individual lines operated by competing railway companies.

Even pioneering bicyclists had had their own maps of London since the late 1890s, a period when the craze for two-wheelers had been so strong that for a while White's in St James's had taken to laying on private breakfasts in Battersea Park for those of the venerable club's well-upholstered members who wished to give these new fangled boneshakers a try. But, incredibly, nothing similar existed for the Underground, at least until 1908 when at last an attempt was made to graphically represent the connected but confused maze of nine different lines which criss-crossed the capital at that time.

The result, alas, was a big mess: the layout approximately geographical, with the various lines shown in different colours and stretched east-to-west in an attempt to increase its readability. Unfortunately much of that same legibility was then sacrificed by a curious decision to print the station names in white on a black background, although in its favour the new map was at least reasonably eye-catching which was more than could be said for many other attempts around this time.

Successive efforts were slightly more diagrammatic, with the lines distorted slightly or artificially straightened. This was done in an attempt to leave more space to display the names of stations, and to make the maps easier to understand – the result was often slightly bizarre.

This last factor was crucial: part of the problem with the network was that the railway lines themselves ran all over the place so that any attempt to produce a geographically realistic representation of the Tube was bound to result in little more than a confusing mess of multicoloured spaghetti. Further confusion arose because of the mapmakers' refusal to abandon the surface details: as a result several otherwise reasonably clean, colourful maps depicting stations and lines were spoiled or obscured

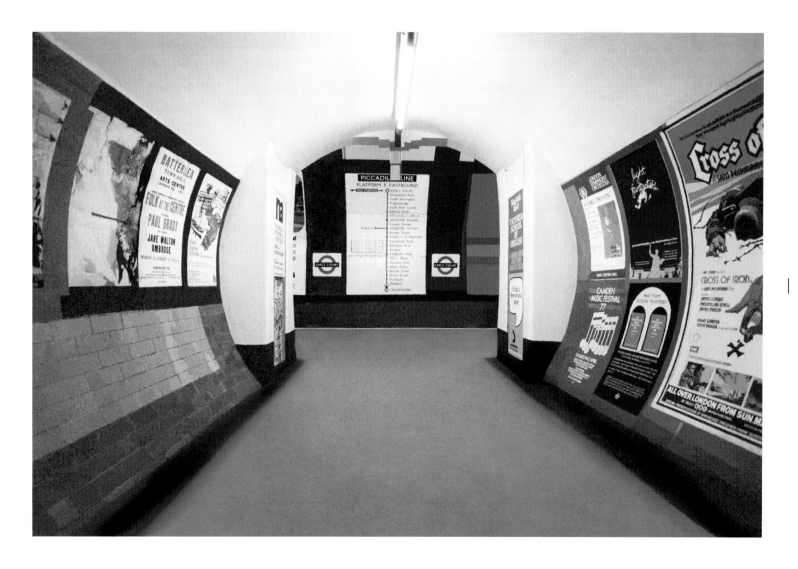

by highly detailed overlays showing the layout of the streets above, parks and even individual buildings.

The first successful attempt to abstract the diagram – by removing these various levels of unnecessary detail, and partially freeing the Underground from its geographical restrictions – was signed 'F.H.S.'. The initials belonged to a draughtsman called Fred H. Stingemore, who on Pick's behalf addressed the problem from 1925 until 1932. Evidently something of a lateral thinker before this term was in common use, during that time Stingemore produced a series of eleven different maps in an effort to illustrate how the network had been consolidated. He also sought to make it easier to understand, compressing the outlying areas of London relative to the more intricate and congested central areas of the City and West End.

Above all, though, Stingemore's contribution was to remove the restriction of the streets, the geography, and to look at the problem in more graphic terms. He did this by retaining the network's approximate layout but removing all of the surface level detail. (This included the Thames, although this was reintroduced in 1926 since when it has remained a useful marker.) Abandoning the need to relate the map to the city above in this way was a masterstroke, Stingemore's sort of non-geographic linear diagram finally acknowledging that Tube travellers did not need to know where they were at any particular point on their journey, merely where they were travelling to.

Thereafter the gradual, painstaking refinement of Stingemore's concept fell to one Henry Charles Beck (1902–74) – always known as Harry – an engineering draughtsman employed in the London Underground Signals Office. He came on board only because by 1931 Stingemore was clearly beginning to find it difficult to accommodate new lines and new stations into his existing map.

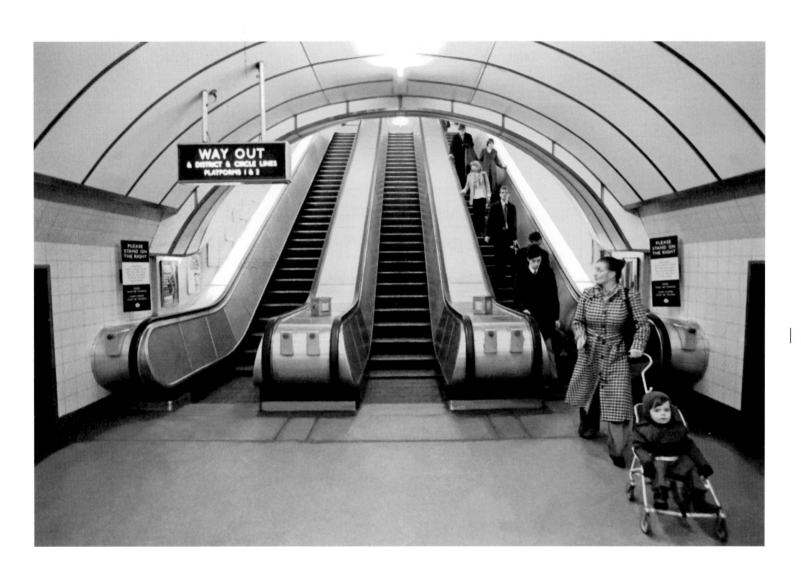

Beck quickly proposed a radical solution, arguing that the network had by now become too large to be represented geographically and that an entirely new concept was needed. Famously, with the management of the Underground still unsure about his proposals, Beck was expected to work on the problem in his own time. But to his credit he was happy to do so and 'looking at an old map of the Underground railways,' he later said, 'it occurred to me that it might be possible to tidy it up by straightening the lines, experimenting with diagonals and evening out the distance between stations.'

One way seemed to be to map the network not as a map of London at all but to do it schematically, much like the sort of traditional electrical circuit diagram familiar to any schoolboy, although neither this nor the vaguely similar topological means of mapping city sewers has ever been confirmed as the source of Beck's inspired solution. To most, of course, it does not matter where the idea came from, merely that it worked – which in Beck's hands it very soon did, the new map providing an intriguing and powerful shortcut to passenger comprehension.

Scribbling his ideas in an old school exercise book, Beck had first sketched out a dramatically simplified version of Stingemore's Tube, showing the various routes and scores of stations new and old. These he cleverly located on a loose but clear grid made up of those vertical, horizontal and 45-degree diagonals with which we are all so familiar today. The result, like Johnston's font, was a masterclass in clarity. Instantly legible and extremely elegant, Beck had brilliantly abstracted the view still further, compressing suburban services so that outlying stations appeared to be no more distant from one another than those closely squeezed into the city centre.

This latter achievement was possible only because the map no longer relied on street plans for its basic geometry or scale: disconnecting the network from the city it served in this way meant the congested centre could be enlarged and the suburbs compressed.

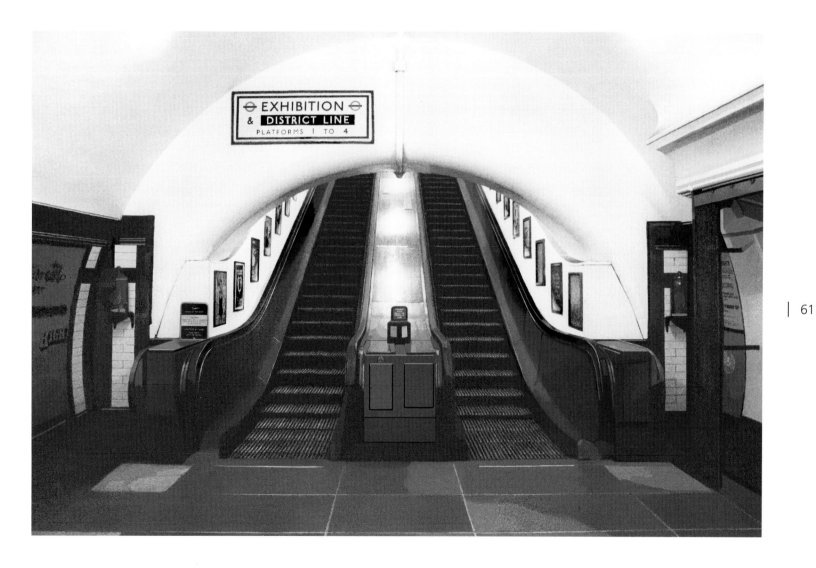

Moreover, just as the real landscape changed only gradually as the traveller moved from city centre to the inner and then outer suburbs, Beck's adjustments to the scale of his map were designed to be imperceptible thereby appearing to unify the sprawling metropolis into one, more comprehensible whole.

No less impressive was the way in which Beck's map (like Johnston with his font, he continued to work away at it for years) was nevertheless still able to describe the layout of the capital and to do so in a way which users could immediately understand. Before Beck there was no easy way to comprehend the plan of a haphazardly arranged city the size and intricacy of London – yet today his map has become the mental picture, the shorthand description of an entire city, which nearly every Londoner carries with him every day.

Beck, in short, had recognised that a good map is not simply a navigational tool but actually a communication device, a piece of pure information, and one which – as many designers and commentators have pointed out since – has all the beauty and elegance of truly good and functional design. Described perfectly by author David Piper as being 'as lucid, stable and pretty in its primary colours as a Mondrian' its art is furthermore something we can all of us appreciate; by contrast most other maps, while clearly useful for anyone seeking to get about, tend to appeal to very few beyond professional cartographers.

Much in line with their early misgivings, Beck's bosses were still unsure about the design, however. They paid him just 10 guineas for all his work – £10.50, equivalent to approximately a fortnight's wages. Even then they were so concerned that the travelling public would prove reluctant to adopt such a radical proposal that the first maps to be printed and distributed included an invitation to Tube users to write in saying just what they thought of it.

For the same reason they authorised only a very modest initial run, in theory to test the market but probably, more cynically, in order to avoid wasting money on a project in which they had little or no faith. In the event the public had no such concerns and took to it immediately: Beck had been right all along, and in recognising the irrelevance of London's geography and of the precise physical locations of individual stations he had hit upon a certain winner.

'If you're going underground,' he used to say, 'why bother with geography? Connections are the thing.' And while it is unlikely that more than a tiny minority of the travelling public spotted this or even gave the matter any thought, tens of thousands of them realised the maps were perfectly suited to the job in hand. That first print run was very quickly exhausted, Beck correct in his assertion that passengers needed only to know how to get from A to B, and where to change lines, rather than how individual lines and stations related to the streets above. The inclusion of the Thames (also represented schematically, and the only surface feature Beck ever permitted) provided all the context anyone needed to interpret, understand and use the map to get around.

Today an original of this first experimental pocket map is a highly collectible piece of London memorabilia, not least because the map was never static but continued to evolve as the network expanded and as Beck continued to tweak his design. Whereas, for example, the first iterations marked individual stations with a blob, Beck quickly replaced these with tick marks for ordinary stations (these pointed to the station name, and put some distance between each one thereby providing greater clarity) and diamonds for those which intersected with other lines.

Further refinements included adjusting the colours of the lines – the Central Line changed from orange to red, the Bakerloo Line from red to brown – and changing the diamond to a circle at those stations where passengers could change lines.

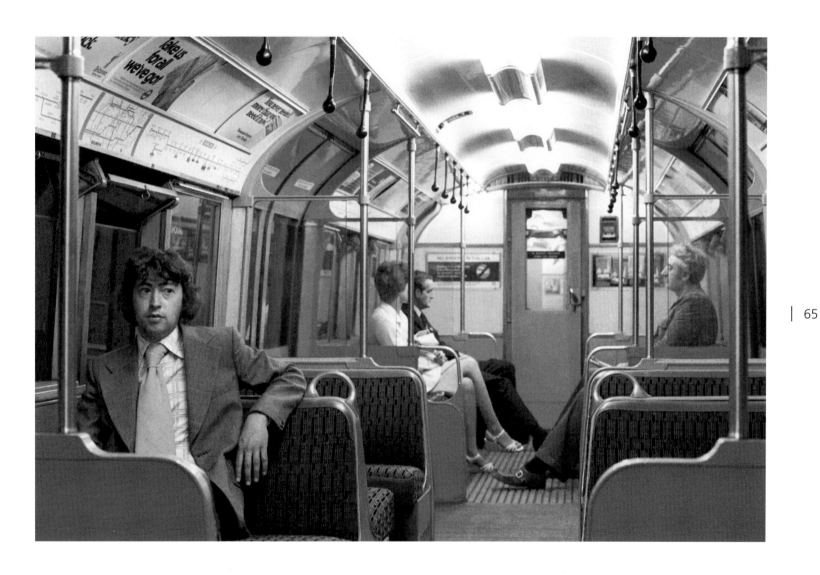

Occasionally other designers were allowed to tinker with the design – Hans Schleger was the first to have a crack at it, in 1939 – but their modifications often displeased the public as much as they upset Harry so that the map in use today still bears a very strong resemblance to Beck's final 1960 design.

That said, its success was naturally not entirely down to Beck. By great good fortune the map's evolution coincided with Edward Johnston's crucially important work on the font, and one can see that a timely switch from capitals to lower case for the station names brought a subtle, more informal feel to the design. Cartographers and others still refer to it as Beck's map, however, and acknowledge his design as the clear prototype for most Continental underground railway system maps. If nothing else that makes it even more remarkable that – while Pick famously turned down all the honours he was offered – Beck himself received no official recognition at all until many years after his death.

Now, at last, he has a plaque at Finchley station; also a gallery named after him at the London Transport Museum in Covent Garden. As late as 2006 his map – still, as Piper put it, 'as elementary and workable as the circuit of a simple crystal-set' – managed to come second only to Concorde in a TV poll to determine the most iconic British design of the twentieth century. Then in 2009 Beck was back in the news when a set of postage stamps was issued depicting his creation alongside other British design triumphs including Concorde again, the K2 telephone kiosk, the mini-skirt, the Supermarine Spitfire, and London's other great transport of delight: the Routemaster bus.

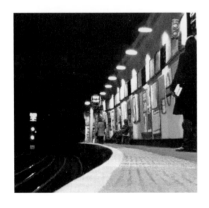

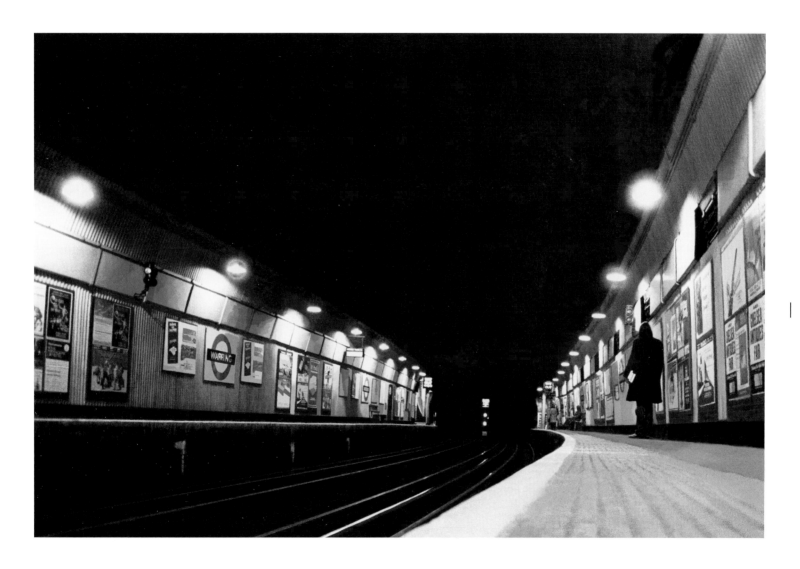

6 ⤞➜

MANY LINES, TWO NETWORKS, ONE SERVICE

Beck's map, Johnston's font and in a less obvious manner the various poster and marketing campaigns orchestrated by Frank Pick went some way towards demonstrating the coming together of the organisation's several services. At the same time coherent marketing and display underlined the status of the London Underground as a single, coordinated network, although the reality was (and is, at least to those travellers who care to look around and notice such things) that the Tube as we know it is composed of two distinct and quite different rail networks.

The first is made up of the Metropolitan, District, Hammersmith & City and Circle Lines, the shallow or so-called sub-surface routes which meander beneath London through relatively lofty, large-diameter tunnels and often beautifully ordered brick-lined cuttings. These were conceived and constructed in the main by Victorian engineers, and in places built to a scale and with a grandeur more reminiscent of

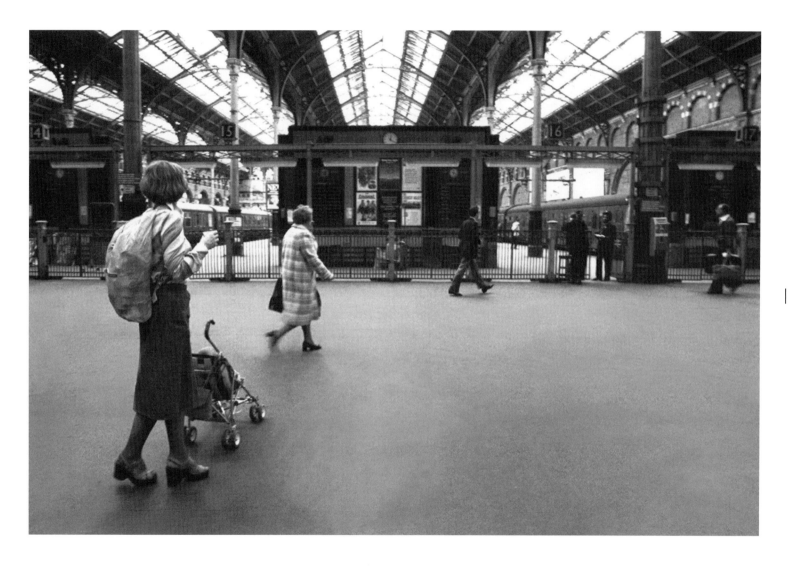

Imperial Rome than old London, their generous dimensions largely but not entirely due to the need to accommodate the funnels of those early, pre-electric engines.

Even now stretches of line run different trains to the rest of the network and until relatively recently, in a subtle nod to an apparently more leisurely era of commuter travel, the Metropolitan A60/A62 Surface stock trains coming in from Amersham were still equipped with luggage racks and coat hooks. The stations on these lines look very different too, being similarly lofty in parts, and (in a faint echo of Charles Pearson's utopian dream) featuring spacious arcades of vaulted brick in place of mean, tiled curve. Provision was also made for proper *facilities*, the sort of things one might find in normal railway stations, such as newspaper kiosks, well tended floral displays on some of those platforms open to the sky, and even licensed premises.

In fact for several decades more than two dozen different stations on the Underground boasted platform bars, some reportedly 'open all hours' having found a way to skirt round the licensing restrictions which had been introduced during the First World War to prevent wayward munitions workers getting out of hand. Sadly most disappeared years ago but the last to go were Pat-Mac's Drinking Den, which in 1978 surrendered its licence on the eastbound Metropolitan Line at Liverpool Street to become an ordinary café, and Sloane Square's Hole in the Wall. Briefly popular after a lightly disguised mention in Evelyn Waugh's *Vile Bodies* (1930) the latter survived until 1985 after which the premises were converted into a convenience store.

Now or then it is impossible to imagine choosing to stop for a pint at, say, Tooting or Pimlico or indeed any of the scores of others stops found on the map of London's second Underground. Excavated more recently than the aforementioned lines, and dug far deeper than them too, this, after all, is the real Tube. Deep, dark and driven through unseen layers of London's ancient geology, at times it burrows more than 200ft below the surface and lies well below the old 'cut-and-cover' tunnels and that other great sub-city tangle of sewers, water mains and utilities.

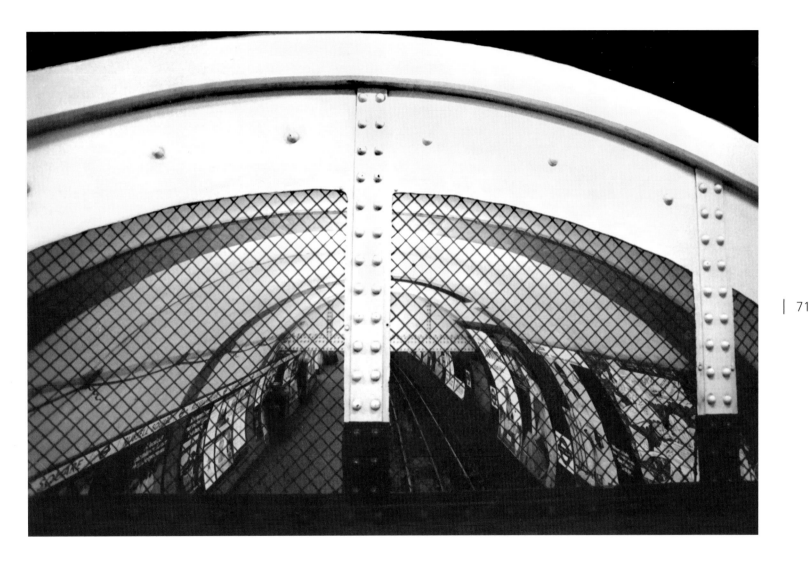

The trains serving those who live and work on the Bakerloo, Central, Piccadilly, Northern, Jubilee and Victoria lines really do run through tubes too. Wrought of steel and concrete, and starkly functional, these lines pass through what are not so much stations as cargo bays, their twisting arteries swelling just slightly at regular intervals to accommodate the narrow, unadorned platforms needed to load and unload each train's calculated measure of fare-paying shoppers and office workers.

These trains are equally specialised too, with a lower centre of gravity than their sub-surface rivals and the geometry of their arched tops minutely radiused to fit the much smaller diameter of the tunnels. For a while some of the trains even boasted a harder ride than their older models, the suspension springs of those cars running on the Central Line having to be shortened temporarily in order to fit through a series of poorly aligned tunnels.

Emerging into the daylight of the suburbs these so-called Tube stock trains look slightly out of their element too, their low, snake-like movements strangely sinister and untrainlike, and perhaps better suited to the dark, sightless underground world of the inner city. (To get the full effect of this, one needs to visit the Isle of Wight. Here the Island Line runs old 1938 Tube stock trains on an 8½-mile route from Ryde Pier through the stations of Ryde Esplanade, Ryde St Johns Road, Smallbrook Junction, Brading, Sandown, Lake and Shanklin. The reason for this is that the island's tunnels are too small for conventional mainline trains, and despite their great age the trains still manage to clock up around 70,000 miles a year.)

When it comes to their utility, however, the two networks – Tube and Sub-surface – are wholly interchangeable, identical, as one. And from the passenger's point of view that is precisely how it needs to be. Pick's challenge was not only to knit these different lines into one, coherent, seamlessly communicating whole but to use new design and new architectural styles to demonstrate that unity and utility to passengers who simply wanted to catch a train and know where it was heading.

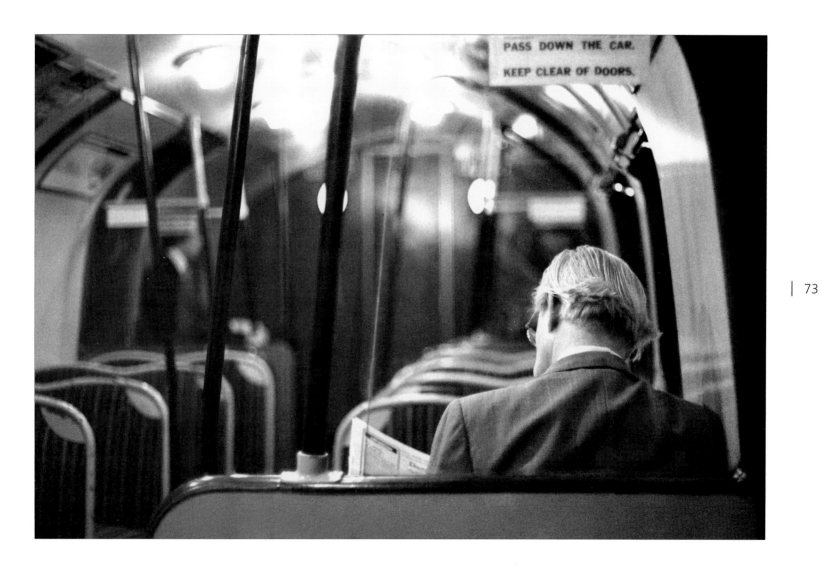

London Underground – architecture, design and history

7 ⇥

ARCHITECTURE II
All Points South

In the architectural arena the taste for a certain kind of Edwardian exuberance did not long survive the First World War, although the appearance of buildings such as the new Bank of England, the India High Commission and South Africa House demonstrated the survival of the Imperial tradition until well into the 1930s. Elsewhere the capital flirted briefly with more exotic influences, such as the Baroque at Unilever House on the river, a Parisian take on the urban for the Ritz Hotel and St Helen's Place off Bishopsgate, and even Egyptian at Adelaide House where fashionable pharonic detailing still provides an interesting contrast to the much earlier Greek Revival Fishmongers' Hall on the other side of the street.

Completed in the mid-1920s, Adelaide House also embraced such new-fangled advances as air-conditioning and a rooftop putting green, although generally it is the case that most of the major new buildings which appeared between the wars looked back rather than forwards. Because of this the few truly modern buildings to

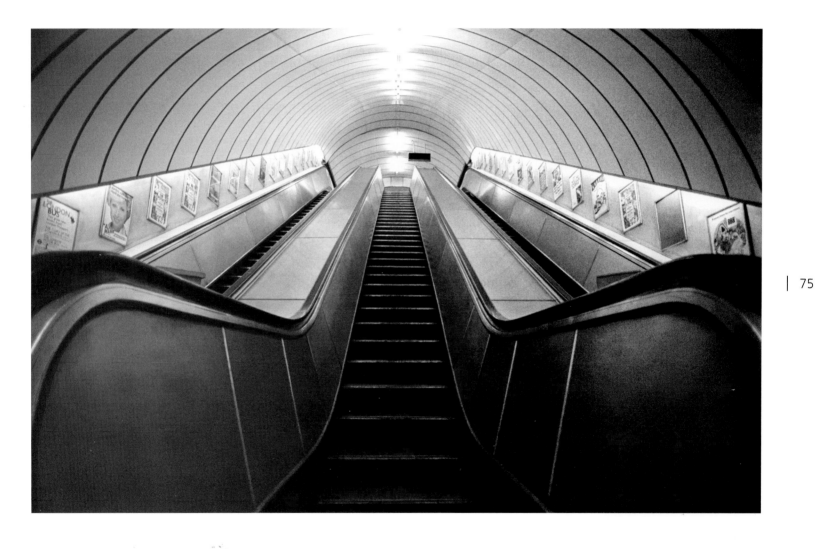

which London could lay claim remained very much exceptions to the rule – this despite Berthold Lubetkin's 1937 well argued assertion that 'England has become almost the only country in which modern architecture can flourish in comparative freedom' – and many still look slightly at odds with their surroundings today.

Among the most famous survivors of this era are Simpson's in Piccadilly (where Moholy-Nagy once designed the window displays), Peter Jones on Sloane Square, the *Daily Express* building in Fleet Street and the Hoover Factory in West London. Unfortunately only one of this distinguished quartet still performs the function for which it was designed, and anyway all four, it could be said, are still as well known for their stark nonconformity as for any perceived quality in terms of their design and execution.

In part this is perhaps only because Londoners still have a tendency to overlook the bulk of their city's modernist architectural legacy. That is to say not the remarkable if occasionally curious and sometimes even playful achievements of Lubetkin himself and of Moro, Goldfinger, Engel and the other middle European émigrés, but rather the scores of Underground stations built on Frank Pick's watch and designed in the main by Charles Henry Holden (1875–1960).

Another to have arrived in London from the provinces, the shy vegetarian Holden was born in Bolton and trained in Manchester after working as a railway clerk and as a laboratory assistant in a chemical works. Briefly a pupil of the architect and planner C.R. Ashbee, he was, like Pick, a Quaker and as a young man was greatly influenced by the philosophy espoused by Walt Whitman in his *Leaves of Grass*. Despite a decidedly shaky start – his father a bankrupt, his mother dead by the time he was eight – Holden had become a nationally established architect long before the mid-1920s when he received his first commission from Frank Pick.

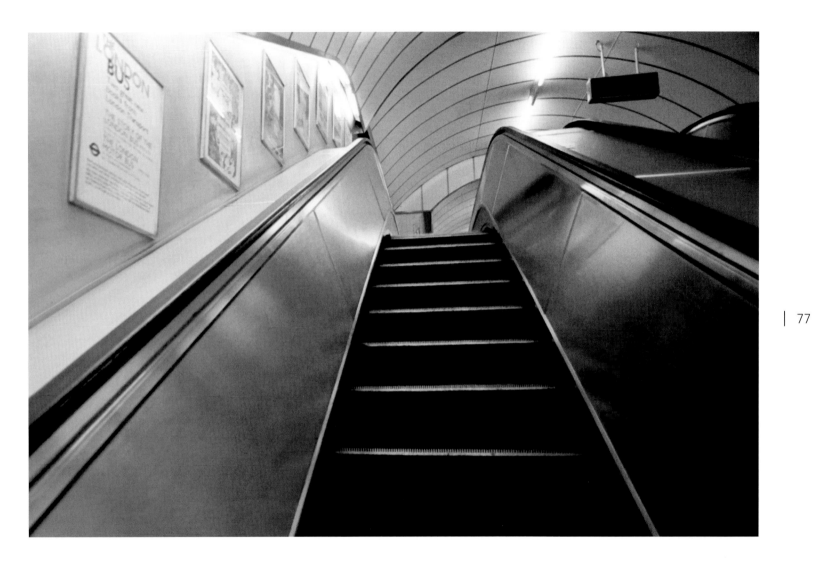

As early as 1902, for example, the twenty-seven year old's design for Bristol Central Library had seen him cleverly combining traditional Bath stone, the Arts and Crafts detailing he then favoured and a structural steel frame. Six years later a new headquarters building for the British Medical Association in The Strand (now the Embassy of Zimbabwe) moved his personal game on further still, before becoming something of a *cause célèbre* when straight-laced Londoners objected to a series of nude sculptures on its façade, carved by an unknown bohemian called Jacob Epstein.

As it happens the naked figures were eventually modified, although the specifically masculine portions of stonework might have been cut back for health and safety reasons as much as for reasons of prudishness. By then the furore had quietened down, and in 1918 Holden was considered a steady and sensitive enough fellow to be entrusted with the aesthetics and architectural elements of more than sixty war cemeteries. These were to be constructed along the Western Front, under the auspices of a new Imperial War Graves Commission for which Holden, a wartime officer in the Royal Engineers, was one of four principal architects.

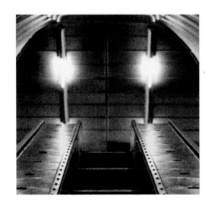

As his work at the library in Bristol suggests, however, besides a certain sensitivity Holden had a profound knowledge of materials and a deep understanding of the most advanced construction techniques then available. A decade later, when he was working on 55 Broadway (now the headquarters of Transport for London) this same, very considerable technical expertise enabled him to design and build what at that time was by far the tallest office block ever erected in the capital.

Now routinely described as London's first skyscraper, at 175ft and with a groundplan of 31,000sq ft, the cruciform structure of No. 55 is unsurprisingly dwarfed by many more recent buildings. But in 1929 – a uniquely conspicuous monument in steel, bronze, granite, marble and 78,000cu ft of Portland Stone – it was a true behemoth. Actually tall enough to pose a serious challenge to the existing London County Council

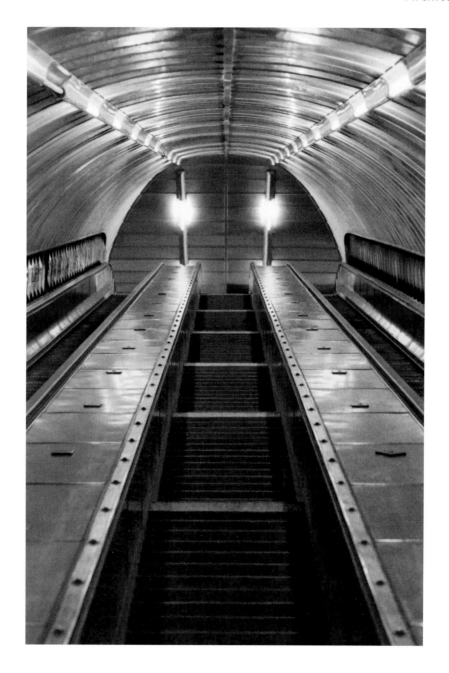

fire regulations, for more than a decade this inflexible rulebook effectively outlawed anyone working in the bright, sunny offices in the central tower which was simply deemed too high to be safe.

The design must nevertheless be considered a triumph – structurally, artistically, and surprisingly too perhaps given that today Holden's name is more often associated with structures at or below street level rather than towering so many feet above it. Once again, though, Holden's work was to prove controversial, and once again it was Jacob Epstein who found himself at the centre of the storm. At sixth-floor level Holden had allowed for eight dramatic carved reliefs, the responsibility for these being parcelled out to a number of avant garde artists including Epstein, A.H. Gerrard, Allan Wyon, Eric Aumonier, Samuel Rabinovich, Henry Moore and the aforementioned Eric Gill.

In due course Gill was to feel a similar cold wind of public disapproval when it became apparent that while working on the BBC's Broadcasting House in the early 1930s he had found time to carve a cheeky relief of a girl's face on the backside of his figure of 'Prospero' (and to leave his 'Ariel' suspiciously well-endowed). But this time it was Epstein who caused the upset, with particular objections being voiced about the physical attributes of two of his figures at 55 Broadway, called 'Night' and 'Day'.

Eighty years on, hearing that Epstein faced various charges of celebrating obscenity, bestiality, pederasty and even cannibalism, it is tempting to wonder just what all the hoohah was about – and not least because one almost needs a pair of good binoculars to identify the root cause. At the time, however, the outrage must have been quite genuine, with one group of citizens attempting to conceal the offending article with a glob of tar hurled at it from a passing car.

Before long the *Daily Mirror, Express, Manchester Guardian, Times* and *Telegraph* were all busy whipping the public into a frenzy using editorials, their letters pages and

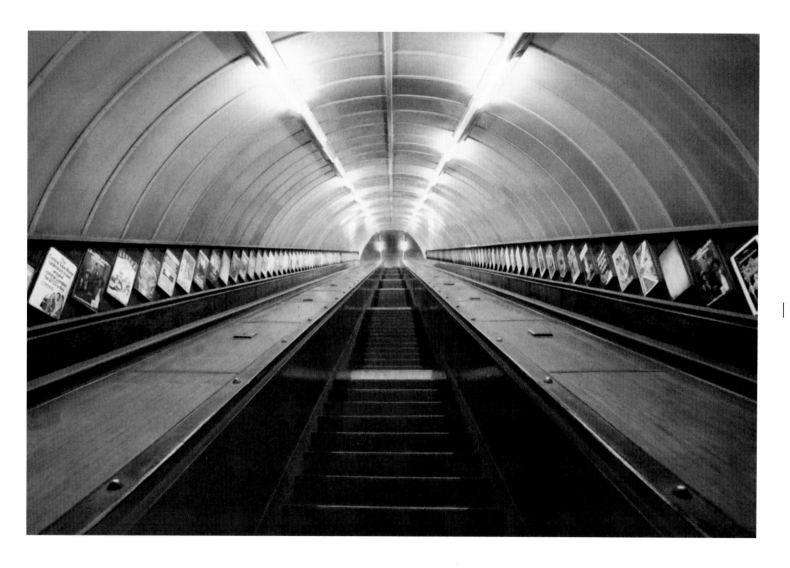

London Underground – architecture, design and history

even cartoons. One well-heeled businessman (with no connection to the Underground) responded by offering to pay to have the two figures removed and replaced – and in the end Pick felt obliged to send in his resignation.

Fortunately this was refused. Instead, under protest, Epstein agreed to reduce the dimensions of one key piece of stonework. For his part, while receiving the strongest support from members of the art and architectural establishments, Holden promised not to commission any more work from the sculptor – as long ago as 1912 the two had collaborated on Oscar Wilde's tomb in Paris – at least for as long as he was engaged by the railways and working for Frank Pick.

Pick and Holden had first encountered each other in 1916 through the Design Industries Association, a newly founded body (intended in part to encourage the adoption of superior design principles from Germany) and of which both were to become leading members. As quietly sober as Pick, and similarly modest – he too was to decline a knighthood, on the grounds that good architecture was always a joint enterprise – Holden's first major commission for his new client was to work on the Surrey extension of what is now the Northern Line.

In 1890, running 3.2 miles from Stockwell to King William Street on the edge of London's Square Mile, and costing £200,000, the old City & South London Line had been the world's first electric underground railway. Somewhat predictably *Punch* had nicknamed it the 'Sardine Box Railway' but the first real Tube soon proved its utility and with a southern extension badly needed, Pick was keen to create something altogether different.

Having already proved his abilities by redesigning the street entrance to the existing station at Westminster, Holden was asked by Pick to build a sequence of seven new stations serving a new stretch of line from Clapham South to Morden. Eventually he

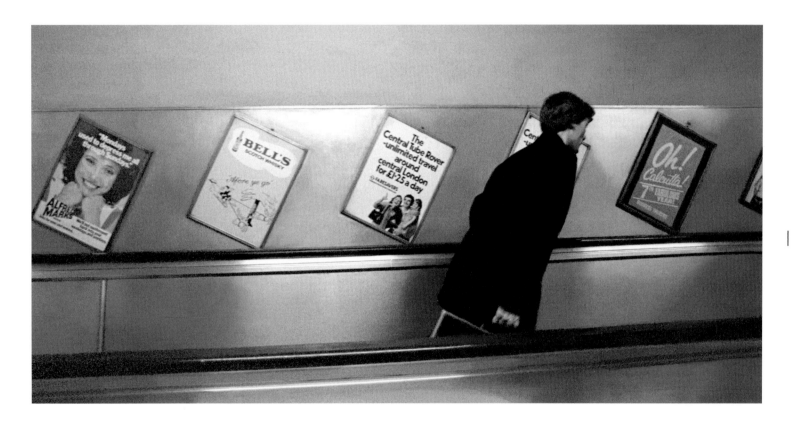

was to redesign a number of other façades on the Central Line too, usually including a projecting canopy displaying the station name in the new Johnston font, but his work on the Northern Line was the first real step on a long path which was to see him cement his reputation as the defining architect of suburban stations, just as Green's work is now emblematic of the inner city.

Keen to find an expression above ground for the unifying network he was gradually assembling down below, Pick wanted these seven stations to look all of a piece. At the same time Holden's design had to be unusually flexible. Whether free-standing, incorporated into existing buildings, or constructed in such a way that they could themselves be built-over straightaway or at a later stage, Holden's prototype needed to be able to fit logically onto a wide disparity of different sites as so many stations – including the first, at the foot of Clapham Common – occupied awkward corner sites at immovable traffic junctions.

84

Having in 1921 been promoted to Assistant Joint Manager of the Underground Group, Pick was from the first hugely enthusiastic about the project, claiming that he and Holden were between them going to 'represent the Design Industries Association gone mad'. Their new joint venture, he insisted, was 'to build our new stations upon the Morden extension railway to the most modern pattern. We are going to discard entirely all ornament. We are going to build in reinforced concrete. The stations [he said] will be simply a hole in the wall.'

To Londoners still struggling to come to terms with the relatively cosy and very English Arts and Crafts style of Leslie Green, what was the beginning of a true Modernist manifesto must have sounded dangerously strident. Clearly, whatever Pick and Holden were planning, it was going to have little to do with the sort of railway stations passengers were used to, neither the friendly, domestic-scale of more traditional dome-and-stone stations in London such as Kennington and Clapham

Common nor much further afield the sort of architecture which today one would recognise as the settings for the likes or *Brief Encounter* and E. Nesbit's *Railway Children.*

Holden's response to the brief, however, was magnificent. While stylistically harking back to his earlier work rather than providing a hint of what was later to come, he succeeded at a stroke in creating what the architectural writer and historian Gavin Stamp was to describe as 'little masterpieces which reconcile discordant street lines and platform orientations.'

The key to Holden's success was the development of a single, simple, geometric, stone-faced concrete box which quietly but firmly renounced period ornament. Determined to abandon architecture's traditional 'mantle of deceits: its cornices, pilasters, mouldings,' Holden continually championed the supremacy of form 'as distinct from the tricks of architectural ornament.' Sufficiently idiosyncratic to be noticed but never outlandish enough to offend, particularly in the suburbs his chaste, simplified Classical style also went some way towards inventing a past for a new population which had never really had one.

There was nevertheless always a slight risk that the façades' cold white stone and large scale could have produced something of a totalitarian air. Fortunately, though, as the tenor of his work moved seamlessly from Art and Crafts to Modernist, Holden managed to avoid any sense of oppression by including a few neat little details, such as spherical London Transport roundels in place of capitals on the square piers subdividing the windows, and very generous use of glass.

With most of these new Tube stations being squeezed on to relatively small sites, Holden also worked hard to ensure that the ticket offices would feel relatively airy and spacious by making these double-height behind the glass fronts. The latter

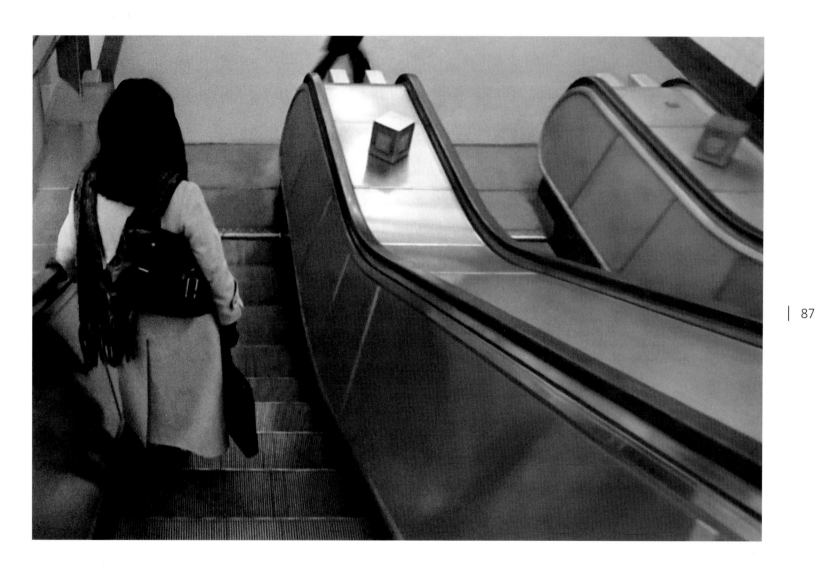

brought a good deal of natural light into the busy booking halls, and certainly more than Leslie Green had managed to achieve with his own approach to station fenestration.

Possibly this last attribute was a lesson Holden had learned early on in his career, during a spell in which he had spent time working on a number of hospitals. Attracting favourable comparisons with Charles Rennie Mackintosh, these had included the delightful Belgrave Hospital for Children opposite Oval Tube, with its wonderful mosaic entrance and Arts and Crafts panelling. Also the Women's Hospital in Soho Square, the King Edward VII Sanatorium in Midhurst, Sussex, and the British Seamen's Hospital at Constantinople.

The architect's extensive use of glass also provided Pick with another welcome opportunity to display his new roundel, these being writ large in stained glass above the station entrance so that the new stations were highly visible from a distance.

It was not to be very long before the essential flexibility of the Holden station design was to be demonstrated when the one at Clapham South was extended both up and downwards. The first modification to his design was the construction of an apartment block which was built over the station in the 1930s (it already incorporated a useful parade of shops). Then in 1940 the decision was taken to excavate beneath it in order to construct one of the capital's eight new Deep Level Shelters designed to shield thousands of civilian and military personnel from enemy action.

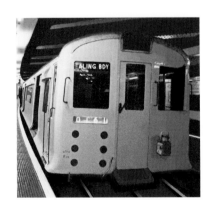

The decision to do this had been taken as the intensity of the German aerial assault increased – no fewer than fourteen Underground stations had been seriously damaged on one single night in December. The public first learned of it when, speaking on the BBC, the Home Secretary Herbert Morrison had announced that with many stations serving as informal shelters, 'a new system of tunnels linked to the London tubes

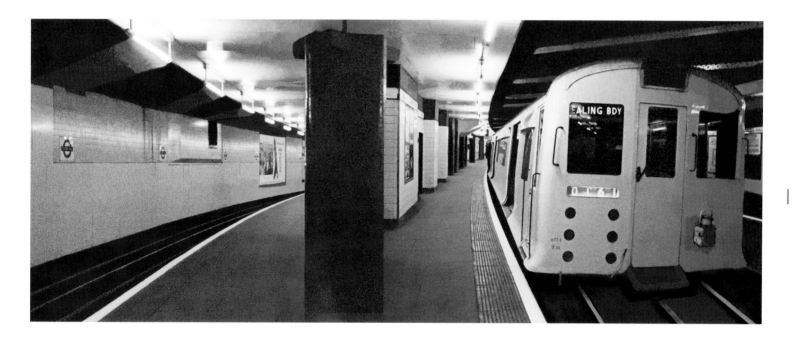

should be bored' in order to provide accommodation for even greater numbers during enemy raids.

London Transport was naturally consulted very early on about this fascinating proposal because in the long term, assuming the country emerged on the winning side, the organisation was expected to inherit the tunnels and have the option to put them to good use. Here the preferred plan was to link up these eight vast, twin-tunnel structures to form a new super-express railway running larger trains at even greater speeds from one side of London to the other. Sadly this latter plan came to nought, although conspiracy theories have continued to proliferate about the secret services having their own transport network running beneath this particular part of London.

The Deep Level Shelters (DLS) were given the go ahead, however, and after considering a number of different options, work began to tunnel beneath the existing stations at Chancery Lane, Clapham South, Common and North, Stockwell, Goodge Street, Camden Town and Belsize Park. (Two more were considered, at Oval and St Paul's, but both schemes were soon abandoned for technical reasons.) Once completed, their twin tunnels more than 16ft in diameter and an impressive 12,000ft long, each DLS provided secure accommodation for up to 8,000 individuals on two separate levels.

Fortunately, even allowing for the exigencies of wartime, the construction work did not compromise Holden's work, although his stations were not to pass the war completely unscathed. Most famously, just after 8 p.m. on 14 October 1940 at Balham, the Luftwaffe unloaded a massive fragmentation bomb onto the street above the northern end of the platform tunnels. Creating a large crater, into which a bus then fell, the fracturing of various sewers and water mains led to the station flooding resulting in the death of 65 civilians and more than 70 others injured.

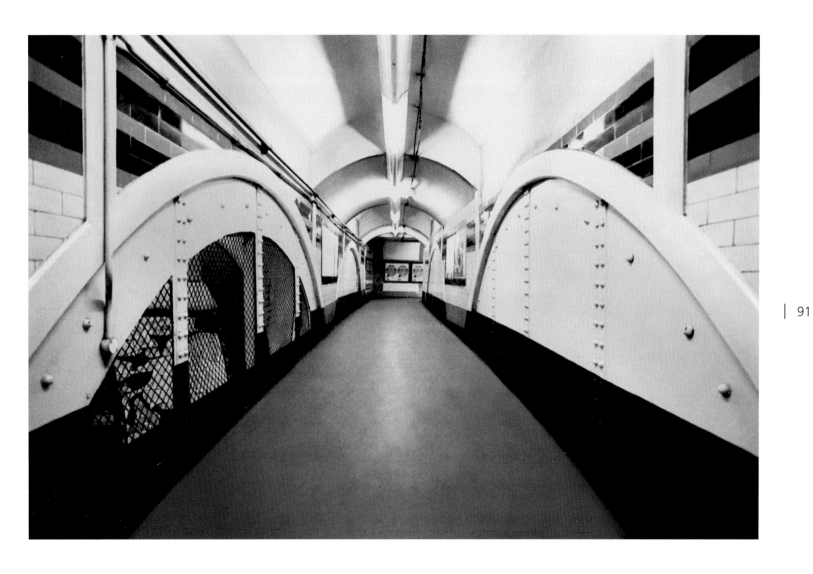

Decades later these early stations – all now listed, except Morden curiously – are still hugely impressive pieces of work although Holden himself, quietly dignified and never a talkative sort, said very little about it once the task was completed. Doubtless this was because he looked upon them as collaborative ventures rather than his own creations, and also because as a relatively shy man he sensibly preferred the finished buildings to speak for themselves.

That said, he was very clear in general terms about the sort of structure he wished to create: one free of fad or fashion and 'which takes naturally and inevitably the form controlled by the plan and the purpose and the materials. A building which provides opportunities for the exercise and skill and pleasure in work, not only to the designer but also for the many craftsmen employed and the occupants.' Even more emphatically, he claimed in 1957 he wanted 'an architecture which is through and through a good building. A building planned for a specific purpose, constructed in the method and use of materials, old or new, most appropriate to the purpose the building has to serve.'

His contributions to the Northern Line certainly fitted this brief, but elsewhere occasionally things went awry. Built to house London University's immense library, administration offices and the School of Slavonic and East European Studies, his Senate House, for example, was intended to 'appear with quiet insistence'. Instead such was the severity of Holden's austere, slightly blunt and overbearing proposal that many lovers of Bloomsbury still breathe a sigh of relief that the university never got around to starting the accompanying suite of seventeen courtyards and faculty buildings which had been intended to cluster beneath a building many people still revile.

In 1949, after all, it was the sinister bulk of Senate House which had provided the model for George Orwell's terrifying Ministry of Truth in *Nineteen Eighty-Four*. In its pages the book's protagonist Winston Smith even appeared to echo the architect's

claim that the building would last 500 years when he noted – and not with any sense of pleasure – that 'it was too strong, it could not be stormed. A thousand rocket bombs would not batter it down.'

A decade earlier Oswald Mosley had expressed a wish to take it over to accommodate a new parliament in the unlikely event of his British Fascists ever coming to power, and he was by no means the most unsavoury enthusiast for Holden's work. In 1940 the building was reportedly put off-limits to enemy aircrew, apparently because Mosley's German overlords liked it too. The rumour at the time – irresistible, and not readily disproved – was that, having found favour with senior Nazis, Holden's creation had been earmarked by Adolf Hitler himself who wished to have it as his Northern European headquarters following the successful prosecution of Operation Sea Lion. True or not, the gleaming white 210ft Portland stone edifice – in which Orwell worked, during his wartime secondment to the Ministry of Information – must certainly have provided a handy navigation point for the Führer's night-time raiders.

8 ➤→

INTERLUDE
Going Underground

While construction work in south London was underway, Holden was offered an even greater challenge when he was asked to completely redesign the station serving what had been the old Baker Street & Waterloo and the Great Northern, Piccadilly & Brompton railways at Piccadilly Circus. This was a notable departure from his work on the Northern Line in that – uniquely at this time – both the concourse and booking hall were to be entirely below ground.

Initially he worked alongside Stanley Heaps (1880–1962), for a while Leslie Green's assistant and subsequently, as the Underground Group's chief architect, almost certainly responsible for the interiors of Holden's Northern Line stations. (Heaps was also the first to design stations specifically to accommodate escalators rather than lifts – at Paddington, Maida Vale, Warwick Avenue and Kilburn Park).

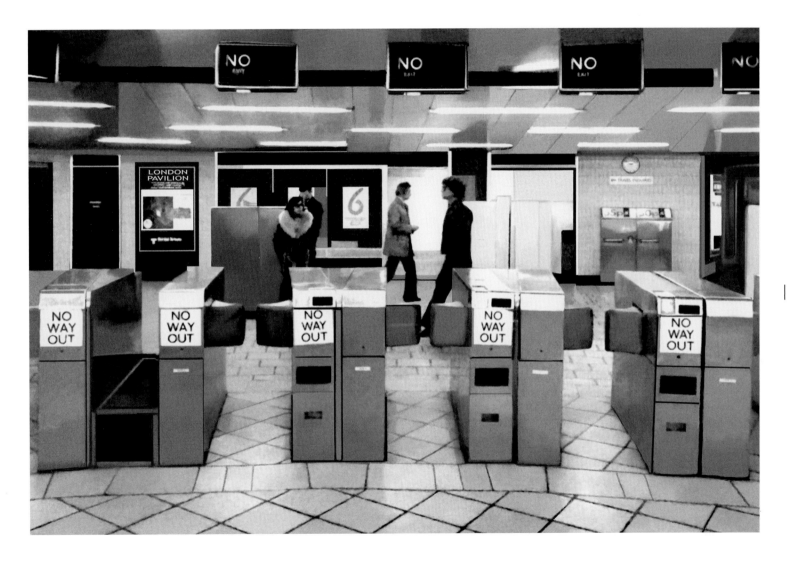

London Underground – architecture, design and history

At Piccadilly Circus the two sought to provide some stylistic echo of the famous architectural landscape above, although sadly at street level the original circular outline was already well on the way to being lost. To do this they attempted in some concrete fashion to reflect the grandeur, form and importance of Nash's original streetscape, Holden's imaginative solution being to devise a large, sweeping elliptical hall or concourse. This would be entered via a number of subways coming down from street level, the whole scheme abjuring even a hint of period flavour or decoration.

The logistical complications were naturally very considerable. The area above the station was a major traffic junction linking some of the capital's busiest thoroughfares. At the same time, and almost without exception, the buildings surrounding the circus boasted massive, multi-storey basements which seriously constricted the site available to the station builders. One early obstacle was removed when it was decided temporarily to relocate the Shaftesbury Memorial Fountain to Victoria Embankment Gardens – that is the chap we know as Eros. Doing so left engineers space to sink a deep, wide shaft beneath the point where his plinth had stood. Thereafter, once an immense and hitherto unmapped tangle of sewers, water and gas mains, and conduits for electricity cables, hydraulic pipes and pneumatic tubes serving the General Post Office had been rerouted through a temporary 12ft diameter subway, the traffic above would be allowed to continue unimpeded through the West End while work continued down below.

The first task was one of massive excavation, the spacious 155ft by 144ft concourse we see today requiring the removal of more than 50,000 tons of London clay. All of this needed to be hauled up the aforementioned shaft, and down the other way over the coming months went more than 3,600 tons of cement, a vast quantity of pre-cast iron segments, nearly 1,000 tons of steel and in excess of 1,000,000 bricks.

But beyond the scale of its engineering, the station had also to impress aesthetically. To give an indication of what was planned a full-sized mock-up of the new concourse

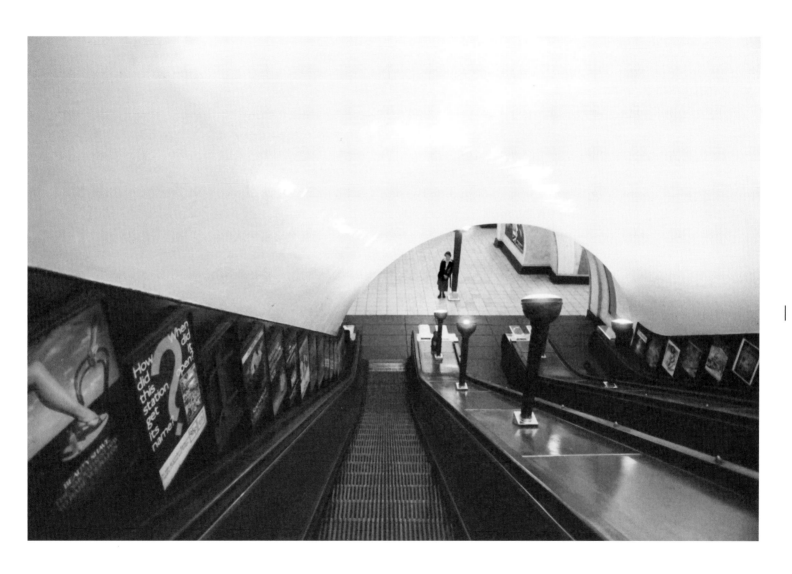

was constructed inside the exhibition hall at Earls Court, while for the real thing Holden decided that almost every available surface – retail stalls, ticket booths and turnstiles, and the station's dozens of supporting columns – would be faced with luxurious marble. Beneath an unusual coffered ceiling, window surrounds and display stands were to be stylishly framed in bronze, while a futuristic world clock was installed enabling passengers in this exciting, new, fast-moving metropolis to monitor time anywhere on the globe as they hurried through.

The whole project took more than three years to complete, and cost the Underground Group more than £500,000, equivalent to nearly £25,000,000 today. Which, by modern standards, actually does not sound that much, particularly given the praise heaped on the designer and his colleagues when Piccadilly Circus opened for business in 1928. To the *Illustrated London News* the new station was 'the best in the world' while another reporter declared that it had been 'utterly transformed by modern architecture and modern art into a scene that would make the perfect setting for the finale of an opera.' A *Sunday Times* critic went further still, insisting 'the art galleries of the People are not in Bond Street, but are to be found in every [Underground] station.'

In fact between the wars plaudits such as these were far from uncommon, and in 1935 one Danish architect had gone so far as to describe Frank Pick's expanding network as one of the seven wonders of the modern world. Efficient in operation, progressive in terms of employees' working conditions, it was perhaps above all boldly Modernist in its creation of a corporate standard encompassing literally everything from the architecture of its buildings to the design of its waste bins and office stationery.

London Underground – architecture, design and history

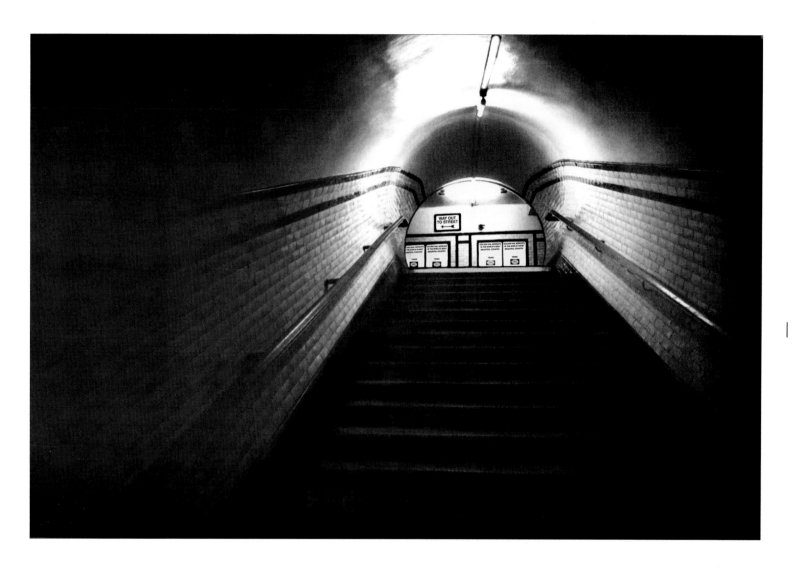

London Underground – architecture, design and history

9 ⇒→

ARCHITECTURE III
Continental Modern

In fact this sort of interest from Denmark was not entirely unexpected as communication among design and transport professionals around the world had been on the rise for some while and the influence and interaction between them had been very much a two-way street. Five years earlier, for example, Pick and Holden had formed part of a small group of senior Underground officials who had travelled through Germany, Holland, Denmark and Sweden armed with notebooks and cameras. The objective was to study continental mass-transit systems, and to better familiarise themselves with European architecture – historic as well as contemporary – in the belief that a deeper understanding of both would enable them better to serve the public.

Returning to London, in the early summer of 1930 the two had presented a paper modestly titled, *A Note on Contemporary Architecture in Northern Europe*. This had been drafted by W.P.N. Edwards (at that time personal assistant to Henry Stanley,

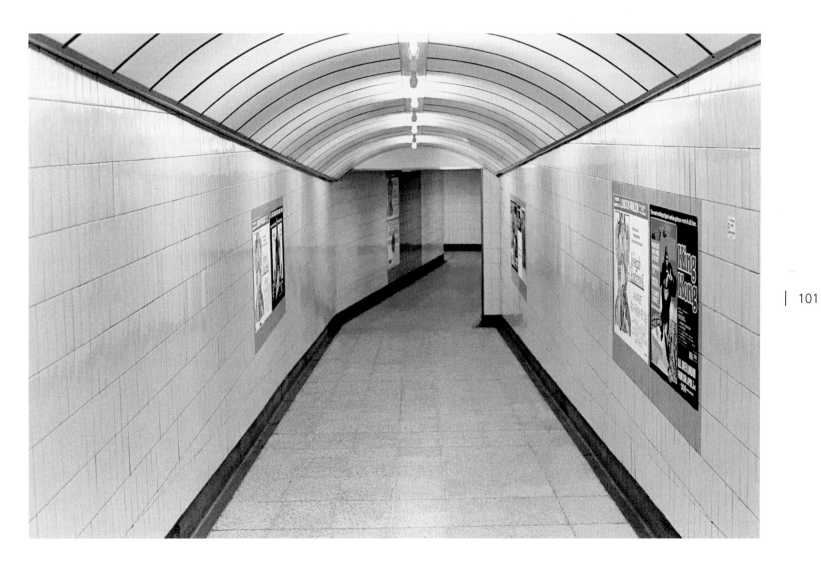

as Lord Ashfield chairman of the Underground Group) and includes a detailed examination of new architectural movements in Europe with a briefer discussion of the few new buildings of the type which had been built in London.

The most important single influence was said to be the development of new steel and ferro-concrete structural elements, the report's author suggesting that their potential (for radically altering the way in which buildings were constructed) made them the equal of the ribbed vault and buttressed arch which had transformed medieval architecture hundreds of years previously. Just as those earlier developments had allowed the imaginations and buildings of medieval masons to soar, so now the structural role of a station wall could be reduced by the modernists to the point where it could become 'merely a covering' for the entrance.

Most obviously, for a man as keen as Holden to bring as much light as possible into the stygian realm of the 'Sardine Box Railway' and its sister lines, the possibilities of mass-produced new materials such as structural glass and steel looked extremely exciting. Certain parallels with the German Bauhaus school were becoming clear too, and while there is no documentary evidence to suggest that Holden met Walter Gropius during that first tour, Pick certainly knew the school's famous founder. (The two were even to work briefly together on an exhibition, in London, later that same decade.)

It was significant too that Pick and Holden made the seventeen-day trip without their colleague Stanley Heaps. From the start he was no supporter of what he dismissed as 'the so-called modern Scandinavian types of architecture'. Returning from his own fact-finding mission a year after Holden's, Heaps had dryly observed that there were 'very few buildings of extreme Modern design in this country, for which I think we should be thankful.'

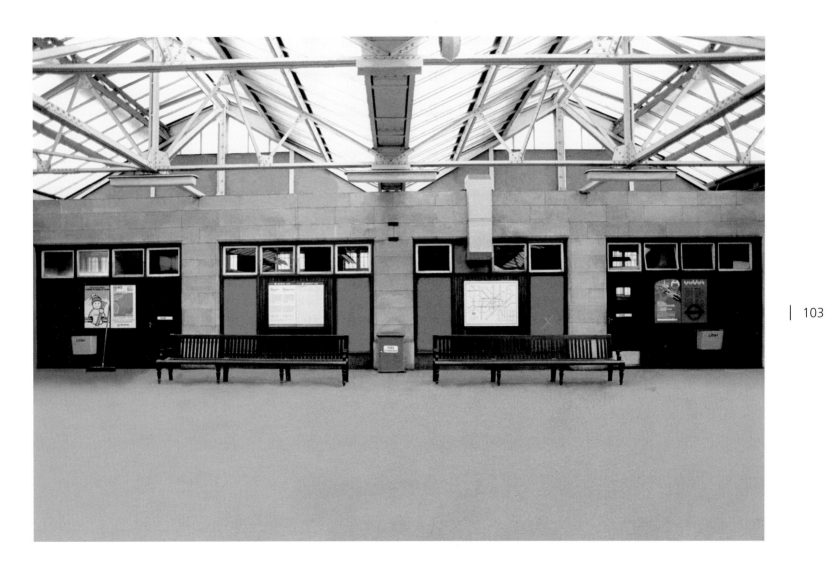

Soon finding himself at odds with Pick, his boss, this enduring antipathy towards Modernist building styles and methods perhaps explains the declining fortunes of Heaps relative to Holden. While the latter continued energetically to push back the boundaries as he moved further and further from his Arts and Crafts beginnings, Heaps persisted in flirting with more suburban styles. With his outlying stations such as Edgware and Brent Cross increasingly characterised by more obviously decorative features – fancy Doric colonnades, neo-Georgian façades and pitched rooflines – Pick finally packed him off to work on a range of less public, less prestigious projects such as train and trolley bus depots.

Holden's first stab at a radical new Dutch Modern-influenced style was a replacement for a mean and inadequate shed which had hitherto served Sudbury Town at the western end of the Piccadilly Line. Distinctly modern but still beautifully crafted, what he devised was essentially a tall, rectilinear redbrick block punctuated by immense panels of clerestory windows beneath a concrete cornice and a vast flat roof.

Both the brick and the roof were very quickly to become Holden trademarks, a pairing he characterised with typical modesty as 'a brick box with a concrete lid.' As a statement it is more than a little reminiscent of Mies van der Rohe's claim – 'I don't want to be interesting, I want to be good' – and left it to others, notably Nikolaus Pevsner in his authoritative *Studies in Art, Architecture and Design* (1968), to explain the true significance of his achievement.

In his second volume, subtitled *Victorian and After*, the highly regarded architectural historian had no hesitation in identifying the new Art Deco station as 'a landmark not only in the history of Holden's work but also in that of English architecture.' Listing Sudbury Town and several others as the best examples of a new approach to station design, Pevsner furthermore found Holden's works on the outer reaches of the Piccadilly Line to be 'modest, functional, yet not without elegance . . . the right mixture of standardisation and variation.'

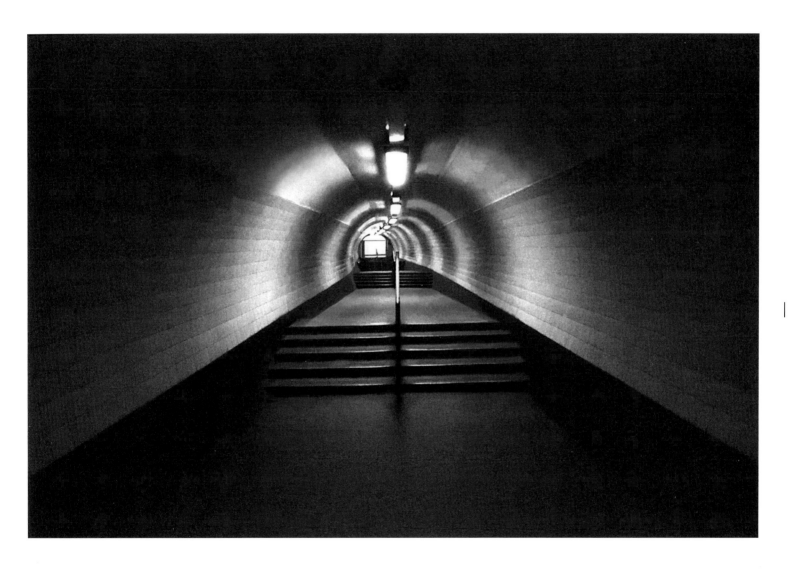

Pick himself was less sanguine, however. He had few if any complaints about Charles Holden's superbly controlled designs, nor his contribution to the revitalisation of English railway architecture. But ever the master of detail, the clutter inside the building caused Pick considerable anguish, and continued to do so from the moment of his initial inspection prior to Sudbury Town opening to the public on 19 July 1931.

Complaining bitterly to a staff member for the 'automatic machines [which have been] dumped down and are now going to spoil the cleanness and clearness of the platforms,' Pick sensed, 'a desire on the part of everyone to break up and destroy the tidiness of this station.' His solution was unusual, however, not to mention calculated and extremely frosty: 'to take no action to remedy the defects to which I have drawn attention in this memorandum.' Instead he wished Sudbury Town to remain exactly as it was 'as a permanent memorial to the department that cannot do its job properly.'

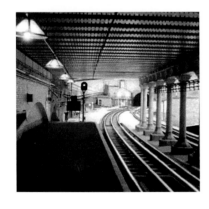

For Sir Hugh Casson, however, even when compromised in this way by insufficiently caring underlings, Holden's new style represented an authentically historic achievement and his virtuosic command of this new architectural vocabulary was something which Casson was quick to applaud. Speaking many years later, to viewers of the BBC's magisterial eight-part series *Spirit of the Age* in 1975, the future President of the Royal Academy argued that 'perhaps the most successful buildings of the 1930s were not the white-walled manifestos of the revolutionaries, nor even the daring experiments of the engineers, but the series of small suburban stations designed for London Transport by Charles Holden.'

Certainly travelling along the outer reaches of the Piccadilly Line today one can appreciate why it is on these suburban stations that Holden's reputation most depends. Piccadilly Circus clearly serves greater numbers; Senate House and 55 Broadway still display a cool dignity and grandeur despite being shadowed by numberless newer, taller and much larger buildings. But on the Piccadilly Line Holden successfully adapted

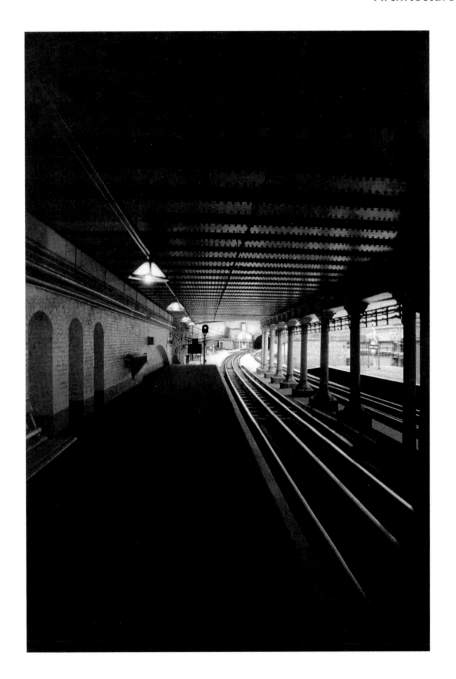

a number of deceptively simple Bauhaus and other European principles to an English setting, and did so in a way which has rarely if ever been bettered.

Combining his stripped and highly selective brand of Classicism with uncomplicated geometry and exposed materials, these stations share a sleek, understated elegance, a combination of simple, honest forms, flat planes and radical curves which gives each an assertive but unabashed poise. At the same time the architect's commitment to quality and his use of bold, plain and clearly delineated volumes – cylinders, blocks and towers – was the perfect complement to Pick's insistence that each part of a building should be truly harmonious with every other.

As a group highly individual, yet as individual creations wholly bespoke rather than clones of one another, Holden's minutely controlled Piccadilly Line stations were in short the perfect partner for Pick's energetically pursued programme to use design and quality to unite and unify his underground rail network – and by extension the capital and people it served.

In Germany, in the artistic sphere, such a thing is known as *ein gesamtkunstwerk*, a complete and all-encompassing piece of work. With everything about Holden's buildings configured to express their very singular purpose, so the lettering used throughout those buildings was designed to complement the architecture. So too, with the same rigour and precision, was this new design language being extended to every other aspect of the stations' exteriors and interiors. From lighting to benches, through ticket kiosks and machines to the clocks and bins, Holden and Pick were effectively drawing up the definitive British blueprint for total design. At the same time, pushing north to Cockfosters, and out west to Uxbridge, their adventure was to see the Piccadilly Line become perhaps the quintessential expression of what a suburban Underground service should be.

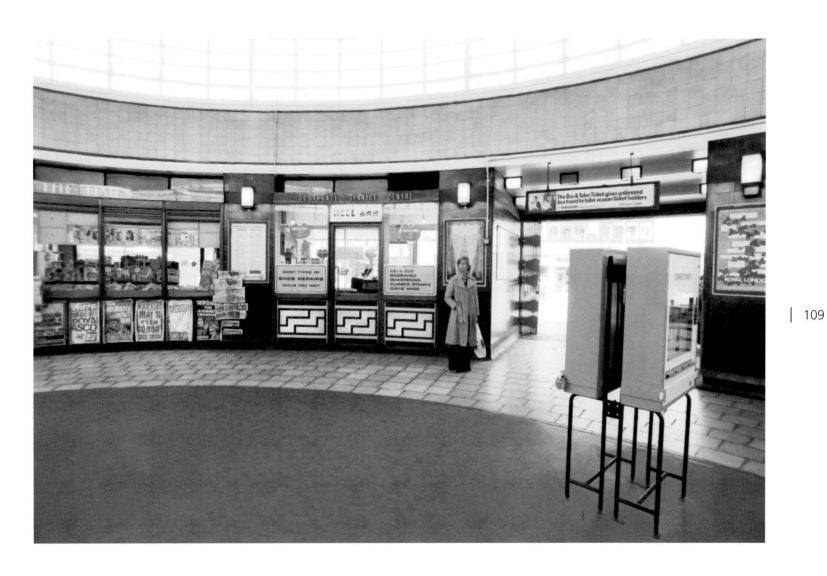

Today, bold, sleek, clean-lined and utterly distinctive, those same classic but somehow timeless station buildings – all of which were designed and even floodlit after hours to make the greatest possible impact – continue to provide what for many with an interest in the 1930s is the most perfect single architectural expression of that decade's preoccupation with progress, swiftness, efficiency and unashamed modernism.

Perhaps the most outstanding of the north-eastern group of stations is Arnos Grove. Typical of the enthusiasts for this exquisite structure, and a huge fan of someone he describes as a 'truly great and still under-rated English architect', is the *Guardian*'s longstanding architecture and design editor Jonathan Glancey. Describing Arnos Grove as a 'king, queen and all princes of a metro station,' in 2007 Glancey included it in the newspaper's list of twelve great modern buildings, arguing that 'it brings together the needs of the modern railway station, the Classical architecture of ancient Rome, the Modern architecture of Holland and northern Germany, gentlemanly restraint and bricky British craftsmanship.'

That said, if Sudbury Town (as its creator continued to insist) was just a box, then one could perhaps argue that Arnos Grove is merely a biscuit tin. But what a biscuit tin! A lofty drum of brick, reinforced concrete and vast areas of glass, heavily corniced and firmly set on a symmetrical brick and glass plinth, the reality is that Arnos Grove is still by such a large margin the finest building in the area that one wonders why it is not more widely known. The locals may perhaps have ceased to notice it, and besides students of design the rest of London is presumably not prepared to make a special trip for a mere station.

Holden's inspirations for it are thought to have included the much larger form of Gunnar Asplund's *Stockholm Stadsbiblioteket* or public library, also the work of the Dutch architect and former military engineer Willem Dudok, and Germany's Fritz Schumacher. But where Asplund's vast rotunda, while indisputably one of twentieth-century architecture's great set pieces, weighs heavily on Odengaten,

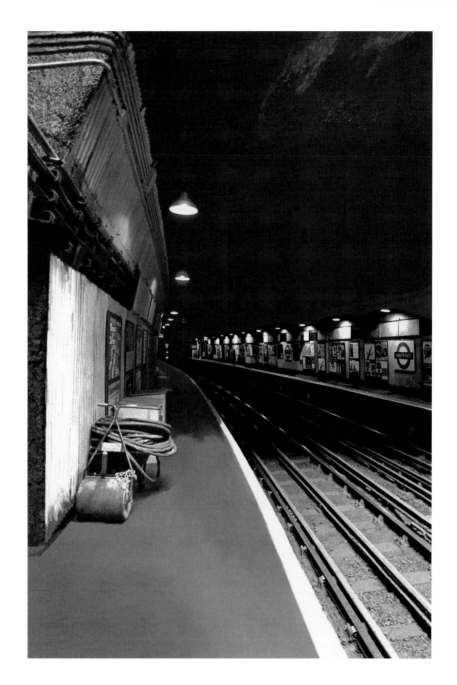

London Underground – architecture, design and history

Holden's draws light and space to it. At the same time, in a flawless echo of Mies van de Rohe's declaration that 'architecture starts when you carefully put two bricks together' its well laid and unpretentious brickwork gives the perfect lift to an otherwise dull and conventional suburb.

Further north along the route described by Harry Beck, the station at Oakwood – originally called Enfield West – opened in March 1933. This was to be the penultimate stop on the Cockfosters extension, although it had been missing from earlier plans which had allowed for just seven stations north of Finsbury Park.

Here Holden created another tall and imposing rectangle, its structure clearly owing something to the architect's successful designs for Sudbury Town and Acton Town but this time employing an even greater area of glass and with the whole mounted on a plinth accommodating shops, storage and offices. As at Arnos Grove the station's dependence on honest, exposed materials is explicitly modern, but here, with its proportions subtly conforming to Classical precepts, the bright, airy ticket hall is more or less a double-cube.

Between the two, at Southgate the same year, Holden returned to the form of a circle but (resistant as he was to gimmickry) eschewed any thoughts of including a pair of opposing vestigial wings to produce something which – from the air – might have mirrored his client's favourite roundel.

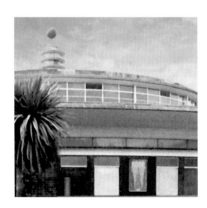

Instead where Arnos Grove towered, Southgate chose to spread: a vast *Streamline Moderne* circle with a projecting concrete roof, the whole topped by a smaller circle of glass which appears to float but is actually supported, umbrella-like, by a single central pillar. Above this Holden placed an illuminated pagoda or Tesla coil, although one suspects that to many modern-day travellers this most distinctive feature looks more like an up-ended Dalek's eye-stalk.

112

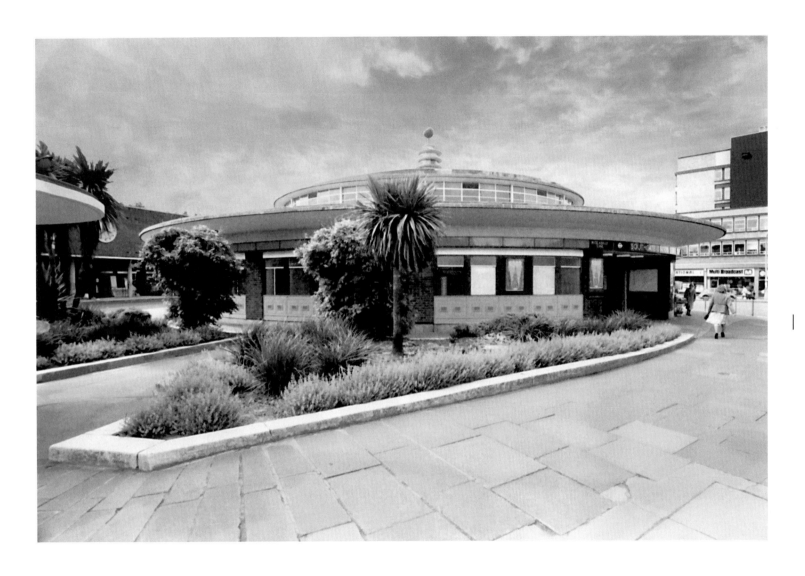

With the whole more suggestive of a flying saucer from Hanna-Barbera's *The Jetsons* than a simple train station, when local residents were offered a free day-return from the suburbs to Piccadilly to celebrate its completion their new station must have looked quite astonishing. Today, its futuristic outline expensively restored, it is easily the equal of anything one finds on the ultra-modern Jubilee Line Extension, the retention of much of Holden's original scheme – including luxurious bronze panelling and striking, column-mounted bronze uplighters for the escalators – making its Grade II* listed interior a popular backdrop for period film and television dramas.

Besides being exceptionally well-crafted, Southgate and its sisters are all distinguished by a certain integrity of spirit as well as the considerable sophistication of their massing. As an architect Holden was unusually good at synthesising the demands of modernity and his profession's obligations to tradition, perhaps recognising (as Orwell was to put it in another context) that 'he who controls the past controls the future'. Devising buildings which were and are genuinely eye-catching, he did so without falling prey to the kind of faddishness or visual jokes which so many of his fellow professionals seem to enjoy even when these tend inevitably to fall flat with the paying public.

At Turnpike Lane, Holden produced another large, plain brick box, this time placing the main station building between two large ventilation towers – either one of which was quickly recognised as an ideal mounting point for a large roundel – a feature which also occurs at Bounds Green. Here again, at both stations, Holden and his team pierced the high walls with segmented windows in order to maximise the penetration of natural light into their booking halls.

Until 1968 two street-level island entrances survived at Turnpike Lane. These were originally intended to provide ready access to the tram services running to and from Alexandra Palace, although this was withdrawn in 1938. (A similar facility was provided

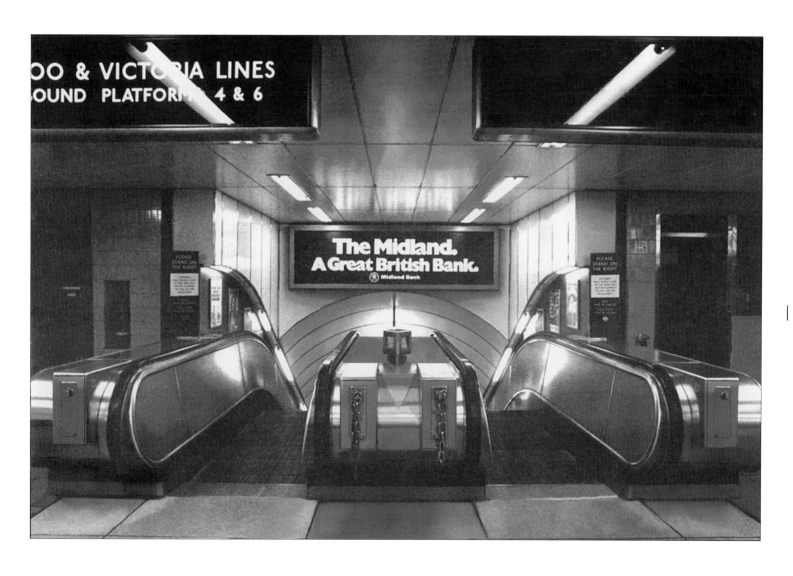

at neighbouring Manor Park, but here too the relevant entrance and exits have since been removed.) That left just Wood Green on this stretch, another well-preserved example, its main frontage curving outwards on its corner site and, again, two tall towers although these are later additions rather than Holden originals.

The ability of railways to boost communities and even create new ones is well known, and historians of London are quick to apportion credit to the Metropolitan Railway for the very significant role it played as midwife to the birth of 'Metroland'. That very phrase was indeed dreamt up by the company's marketing department, although care was taken to ensure that its precise borders remained fluid. For Hugh Casson Harrow was its capital, while Arthur Mee, journalist and bestselling author of the *King's England* series, saw Wembley as its 'epitome'. Refusing to confirm either judgement, the publicity material merely described it as 'a country with elastic borders that each visitor can draw for himself'. Instead the emphasis was on making frequent reference to 'the healthy and bracing air', to regular train services 'unequalled for frequency and rapidity', and to the fact that prospective new residents would soon be able to travel effortlessly 'to and from the City without change of carriage'.

But here too, as the Piccadilly Line forged its own path out of the inner city, Londoners were beginning to witness something similar. Just as today's town planners and city fathers in depressed areas look to expensive new art galleries and 'signature buildings' by big-name architects to turn the tide of failure, so in the 1930s Charles Holden's Piccadilly Line stations were seen very much as vanguards in the move to expand the capital.

Arnos Grove was a typical example of this kind of social and geographical engineering: in 1930 it was an insignificant part of Southgate rather than a discrete area a visitor would have recognised in its own right. For literally centuries there had been little or

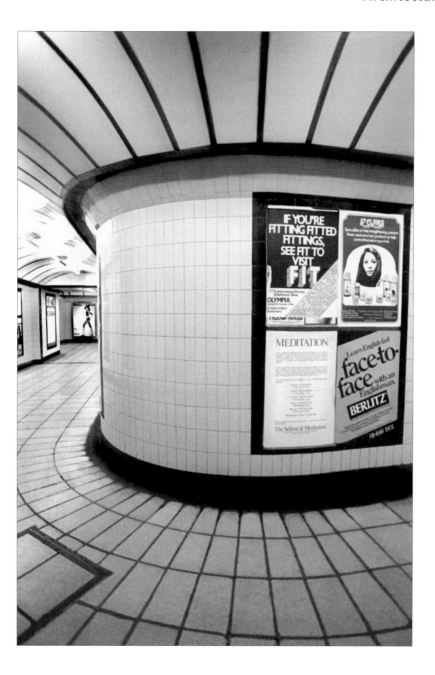

nothing of note out there, besides the remains of a country estate named after the sixteenth-century Arnold family (hence Arnos) and a few scattered smallholdings. The completion of the Cockfosters extension changed all that, however, and with incredible speed: Holden's iconic stations presaged such huge and rapid development that within just five or six years much of what had hithero been uninterrupted open countryside was covered by rows of houses with the population mushrooming.

Similar moves were afoot at the other end of the line too, posters on the Underground asking explicitly 'Why not live at Sudbury Hill?' beneath friendly illustrations depicting wide spacious streets lined with neat semi-detached dwellings. Outside children play on the pavements, while their parents enjoy the leisure to garden and gossip. In case the visual message is not quite clear enough, the benefits are also spelt out in beautifully legible print: 'small, modern, labour-saving houses with garages and gardens. Live in the country where you have room to breathe' – and with a monthly season ticket to Charing Cross a mere 24s 6d.

Frank Pick's messages were working too, so that by the middle of the 1930s an astonishing 2.5 million people were travelling into and around Greater London every day. With only a tiny, tiny minority of them in private cars, a quarter of a million men and women were employed in the transport sector, a substantial proportion of them working for London Transport.

Of course London's expansion was by no means solely down to the Underground, nor could Holden take all the credit – not that he would have wanted to – for the successful development of Middlesex. Instead throughout his long career he remained a partner in the same architectural practice – Adams, Holden & Pearson, which survived him into the 1970s – happily observing that just as he was subject to external influences so his own work had a positive influence on his fellow professionals.

Alighting at breezy Park Royal, for example, one encounters many Holden characteristics including those same simple, geometric shapes, plain red brick volumes accented by strong glazing (both horizontal and vertical), and a bright ticket hall beneath a large circle of clerestory windows. Above this a tall square ventilation tower hoists the London Transport roundel high above the busy A40, but in fact the station is the work not of Holden at all but Herbert Welch and Felix Lander, both of whom were also busily instrumental in advancing the thriving garden city movement.

At Uxbridge and East Finchley Holden's influence was more hands-on. Here he worked alongside the Scotsman Leonard Bucknell, although the red brick façade of the former is perhaps not entirely successful. The strange paired sculptures over the station entrance work well enough, representing stylised wheels with leaf springs; but they are set above what looks like two denuded fireplaces.

East Finchley is a more solid and coherent design, built on rising ground adjacent to the railway bridge and the High Road and topped by a lofty ship's figurehead of a kneeling archer. Twice lifesize, this was created by Eric Aumonier, one of Holden's collaborators at 55 Broadway. The Art Deco figure appears to have just loosed an arrow from his long bow, the weapon aimed towards Morden at the far end of what until very recently (at 17.25 miles) was still the longest continuous railway tunnel in the world.

Bucknell himself was not prolific, however, preferring mostly to write and teach at the Architectural Association rather than practice. Of the few buildings he did complete, East Finchley and his little pavilion for the playground at Coram's Fields in Bloomsbury perhaps best demonstrate his interests and his skill at successfully reinterpreting simple Classical forms in a spirit appropriate to the 1930s. In this he would have found Holden to be a receptive partner, a man whose general rule, pithily expressed, was always 'when in doubt, leave it out'.

10 ➤→

THE WAR AND AFTER

A good deal of further work which Pick had planned for the Underground was suspended in 1939 or even cancelled, excepting those cases where – like the DLS – that work was considered essential to the war effort. Holden accordingly cleared his desk, and Frank Pick moved into and then out of the Ministry of Information after rowing with Churchill. He died in 1941 leaving Holden to spend much of the next six years working alongside William (later Lord) Holford on town planning and other issues concerned with post-war relocation and reconstruction.

Holden returned to the fold immediately after the war, however, picking up where he had left off and resuming work on a number of Central Line stations on London's eastern fringe. With Pick gone London Transport must have been a radically different organisation, and the station at Redbridge, which opened in 1947, was to be Holden's last with neighbouring Gants Hill one of the most astonishing.

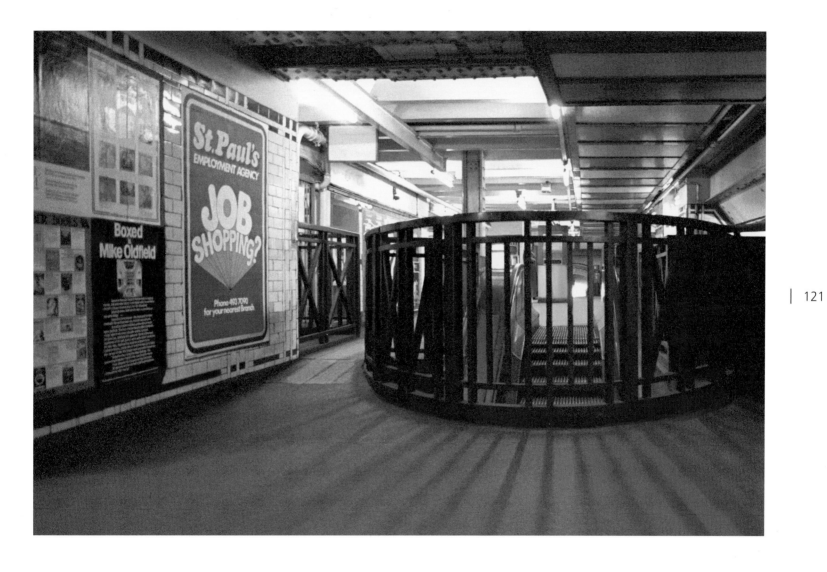

Work had begun here in the late 1930s only to be halted once the scale of the impending war became apparent. Part of the station tunnel was hastily fitted out as an ad hoc air-raid shelter, while in one of the most extraordinary schemes of the 1940s 2.5 miles of twin tunnel between Gants Hill and Newbury Park were turned over to the Plessey company for conversion into a top secret underground armaments factory.

Here, deep underground, an estimated 2,000 staff were employed around the clock making electric wiring looms, transmitters and receivers for Short Sunderland flying boats, Spitfires and Halifax and Lancaster bombers. At the time it was said to be the longest factory anywhere in the world, which sounds reasonable, some of its more sensitive assignments including the construction and testing of the highly sophisticated electromechanical 'bombes' used by the Enigma machine codebreakers at Bletchley Park.

The unusual, linear shape of the approximately 300,000sq ft production line required the installation of an electric railway to serve literally hundreds of work stations. Unfortunately this was of entirely the wrong gauge to be used later for passenger transport, and it was taken up and scrapped in 1945 so that the Wanstead loop could finally be incorporated into the Central Line.

While new lines were being laid Holden's task was to work on the stations themselves. At Redbridge – famously the shallowest deep-level station, at just 26ft – he devised a large and striking ribbed circular skylight for the ticket hall. Gants Hill clearly posed a bigger problem, however, being located (like Piccadilly Circus two decades earlier) beneath a busy traffic interchange. His solution was nevertheless to prove a *tour de force* making the new station by far the most striking on this side of London. Planning another vast new underground concourse, Holden placed this new one beneath a lofty barrel-vaulted ceiling of such elegance and luminosity that it was soon being compared to Stalin's elaborate and lavishly fitted showpiece, the Moscow Metro.

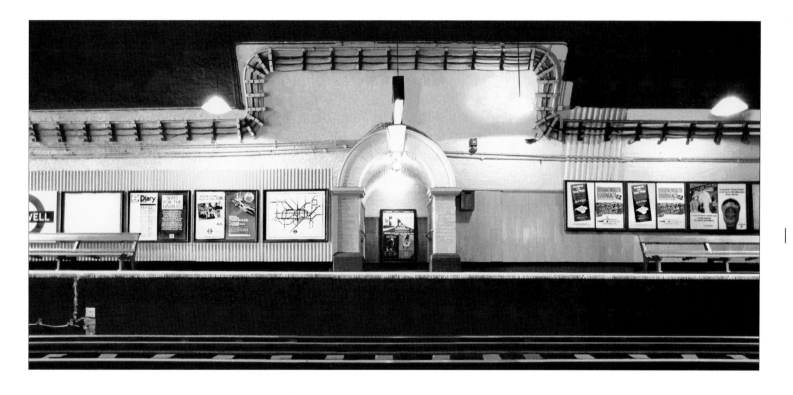

Needless to say it had none of that network's stylistic excesses, Holden like Le Corbusier instinctively recognising that 'simplicity is not equivalent to poverty; it is a choice, a discrimination, a crystalisation.' Instead, as his obiturist Charles Hutton was later to put it, Gants Hill exemplified the way in which Holden 'with an unerring sense of composition based on tradition and natural form, a sympathy for material, and an instinctive sense of construction . . . continued to simplify his work until it achieved the simplest expression of purpose.'

Even without succumbing to the Soviets' taste for marble, mosaics, sculptures and chandeliers, however (such a bold statement might have seemed a little *de trop* out here in the suburbs), an unashamed hymn to Modernism in an environment where a certain stagnating of taste means that mock-Tudor is generally the default choice. But in 1951 Holden's design received a prestigious Festival of Britain Award for Architectural Merit – another recipient was Oliver Hill's magnificent, arched bus station at nearby Newbury Park – and looking back half a century on it is hard to argue with the judgement.

In particular the station was likened to Pushkinskaya station with its immense wagon-vaulted anodised aluminium ceiling, and indeed even now it is known locally as 'Moscow Hall'. Nor were the similarities entirely coincidental as comrade Stalin's famous subterranean 'palace of the people' is certain to have been included on a tour of the Soviet network which had been organised for Underground designers and engineers before the war.

There was never any formal relationship between London Transport and the Moscow Metro, but the two organisations were in regular communication at this time. Indeed by making that trip to view the Russians' considerably more spacious subterranean chambers – the best of them complete with chandelier lighting, marble columns, sculptures, mosaics, paintings and even stained glass – the British delegation were allowing the Russians to repay them in kind. Similar hospitality had previously been extended to the Soviet planners and engineers when numbers of them had travelled to London to look at our Underground while the details of their scheme were still being worked out.

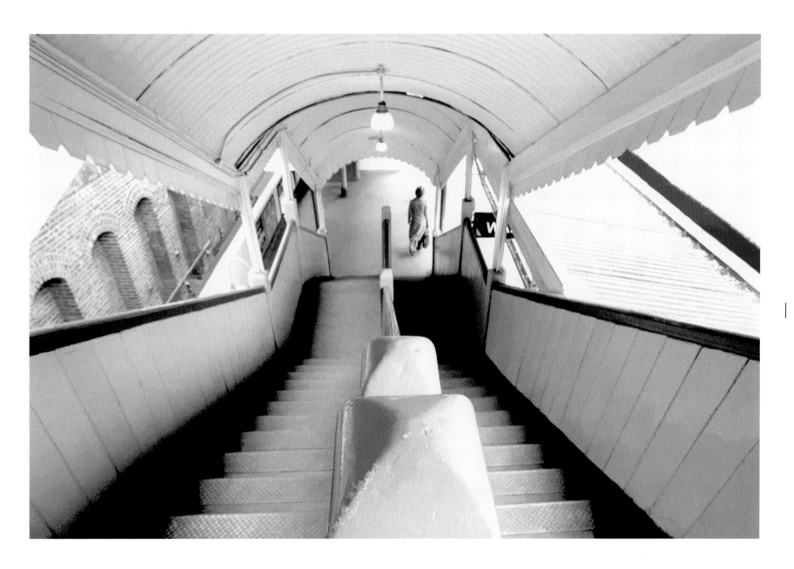

Prior to this the Russians had reportedly favoured the adoption of a much cheaper, shallower cut-and-cover system – not unlike the German *u-bahn* trenches and our own District and Metropolitan lines. But reports from technicians returning from London soon changed Stalin's mind on that score, with no less an authority than Nikita Krushchev claiming that the rapid switch to proper, English deep-level tube tunnels was mostly down to him. His reasoning was typically sound, if a little sinister; 'Keep in mind the possibility of war,' he told readers of his memoir, *Krushchev Remembers*, 'and you'll see that the tunnels with their reinforced shielding and buttressed walls would make excellent bomb shelters.'

The Soviets were clearly grateful for the idea too, as in 1935 Frank Pick was awarded the Honorary Badge of the Moscow Soviet of Workers, Peasants and Red Army Deputies. For a Western administrator to be honoured in such a fashion by a Communist dictator was surprising to say the least – although perhaps no less surprising than Pick's decision to accept it.

126

Why he did so remains a mystery, especially as he was so quick to decline similar honours offered to him by his own country. Certainly it would have had nothing to do with personal pride, as this was not in Pick's personality, and anyway even if he had been interested in creating his own legacy he already had one which eighty years later is still there now for anyone to see simply by buying a ticket.

It may no longer be quite the exemplar it was in Pick's day, when design was seen as a force for social good rather than just an efficient driver of consumer-based economics, but London's Underground still functions to keep the blood of the capital's commercial and daily lives flowing through its veins and arteries. It continues to provide the best possible demonstration of how an efficient, well-designed network can unite a great city – just as Frank Pick argued that it would 100 years ago.

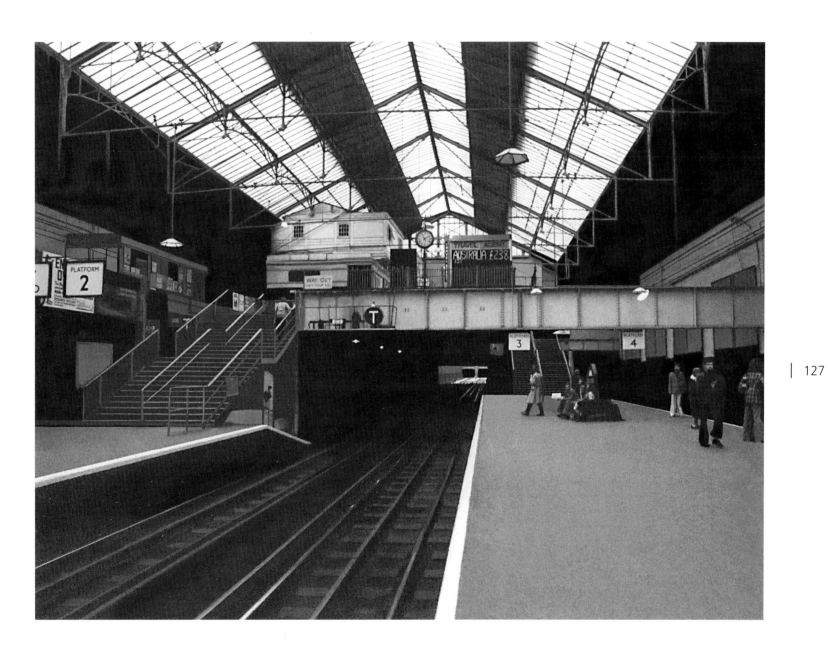

THE PHOTOGRAPHER'S STORY

I picked up my first SLR camera in 1973, and immediately knew I had found my niche. I had grown up in what I called the emulsion district of Los Angeles, an area with dozens of professional photo stores, labs and knowledgeable sales people who were all photographers themselves. So, when I landed in London in August 1976, not only did I begin shooting everything that interested me, but I was keen on finding photo stores abuzz with photo talk and massive supplies. I searched and searched.

Then one day, about two months later, I literally fell into the basement of Campkins Camera Centre in the West End, and met Roger Horsnell who was the darkroom specialist. As he fixed the heel of my shoe, giggling about my falling into his arms, we chatted about photography. I had found my camera bud. He became a good friend and critiqued my work.

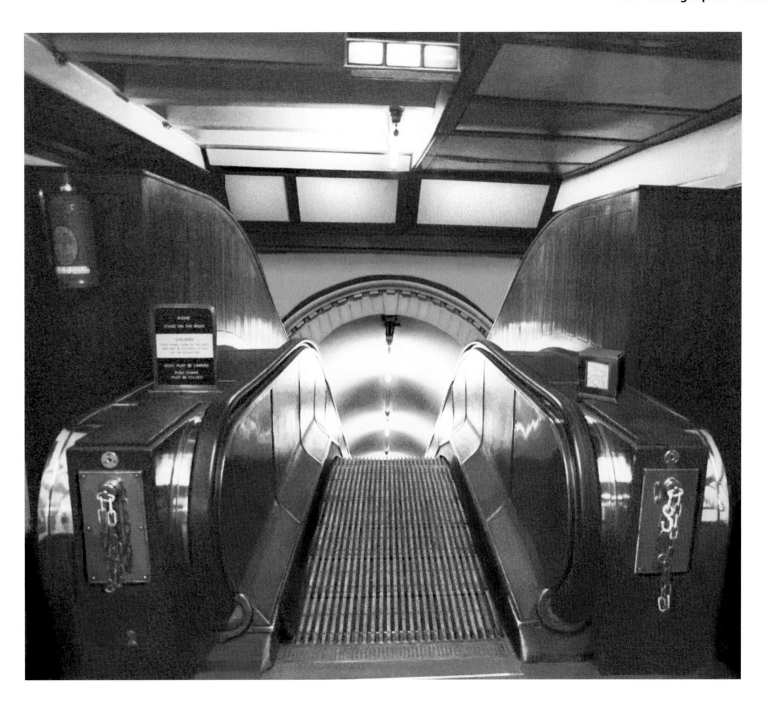

Concomitantly, cameras always around my neck, I took my first shots of the London Underground on that first visit to Campkins Camera Centre. I went home that day, mixed my chemicals, and developed my film. I chose two negatives to print from that day's shooting, and as magic happens in the developing tray, I was stunned by the beauty of these two London Underground images as they appeared in the developer. I was hooked. I had found my subject. These two images also set the visual style for the collection. Mostly void of people, I was enamoured by the Tube's structural beauty.

As it never rains underground, this was perfect. Cameras don't like the rain, and as I had been drenched carrying four filled-to-the-brim grocery bags on my first shopping day in London, I learned quickly that one must always carry an umbrella and have a waterproof cart. So, equipped with a cart now stuffed with stones (pounds) of camera equipment, I began shooting the London Underground. As I was later to learn, having been reprimanded by a Tube employee as well as having been chased out of a couple of stations, shooting the Tube was illegal. The Irish Republican Army's bombing campaign was rather active at the time, so my trusty cart helped to hide my intentions from the prying eyes of Tube employees.

130

So, in one of the most beautiful and interesting cities in the world, I became a mole, travelling hundreds of miles exploring one stop after another, never knowing what was above ground. Unless I was running errands or visiting friends, I never left the stations because it would cost to get back in. On days whereby shooting the Tube was the sole agenda, I'd pay the lowest fare, hop on the train, and would never leave the system until I arrived home. I lived in Putney. One time and one time only, however, I changed my modus operandi and decided for the fun of it, to go above ground just to see where this train had taken me. To my surprise, there were palm trees. Palm trees in London? Huh? On top of that, the Southgate station looked a bit like a drive-in restaurant I used to frequent in Los Angeles. I winced, had I not been in my right senses I might have thought I had crossed the pond back to my hometown.

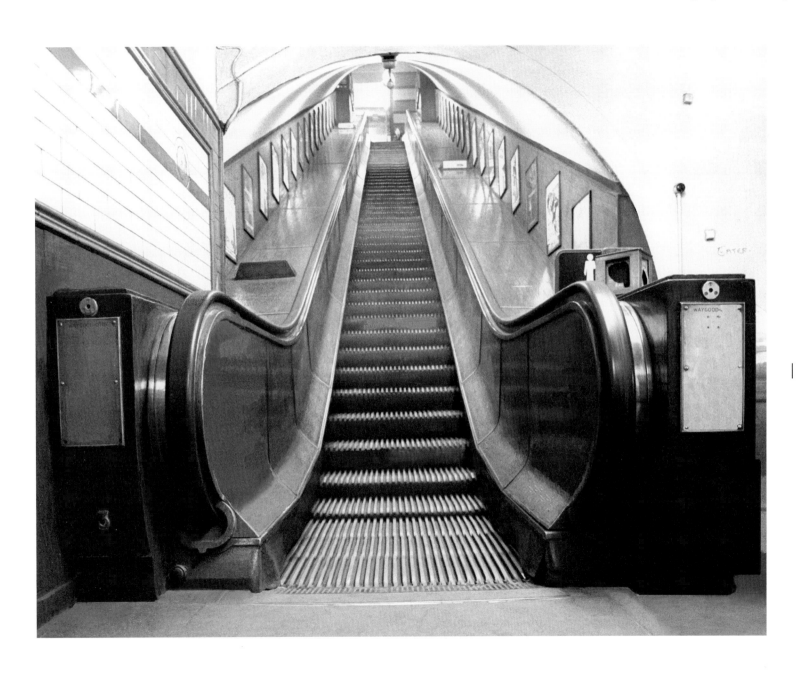

131

It made me wonder what I was missing by not going up for fresh air, but I continued on with my original plan.

Being an American who had grown up in a town devoid of a decent mass transportation system, as well as not having my own motor transport, I loved the Tube and train system. I was probably more likely to see the beauty within this system than the average commuter. Always drawn to architecture, I also sported a strong sociological viewpoint, an historic sensitivity and an imagination that travelled with me through this labyrinth. I imagined Watson yelling 'Holmes' as Moriarty vanished into the crowds at Baker Street station – no pictures of Holmes on the station walls in those days.

I imagined the war years, and what it must have been like to seek safety in the bowels of London as Hitler's bombs devastated the city above. The war was still a main topic in the pubs at the time I was there.

At Bank, the financial district, I noticed that the car seats were cushier. I actually saw the cars regularly swept clean, a rarity at other stations. They had queueing up lines painted on the platform though I had never seen anyone honouring them. It was here that I witnessed briefcase-carrying commuters in bowler hats mingling with flat cap patrons. I didn't know bowler hats were still in fashion.

Elsewhere, I ran into, what I was told were, 'gentlemen of the road'. Americans would have called them hobos during the Great Depression of the 1930s. One such fellow was extremely savvy. He was a well-kept robust gent, quite handsome, whose fine features were framed by a beautifully manicured silver beard. He was draped in a black floor-length overcoat and his feet cushy and fattened by what must have been due to his wearing five clean white socks per foot – certainly for warmth and probably for comfort too. I wanted a shot of him, but he was aware of my agenda. He was canny. He watched me out of the corner of his eye. I quickly put a 20mm lens on my

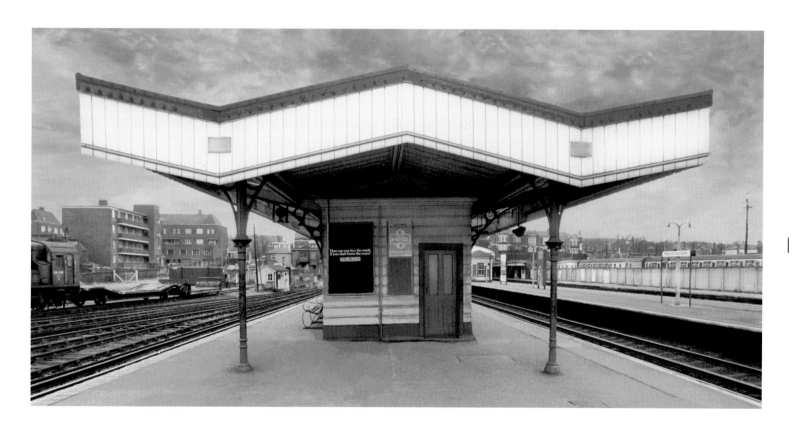

London Underground – architecture, design and history

camera, thus I could point my camera at the train and still have him in the frame. But, no! He knew exactly what I was doing, clever man.

The British are a funny lot, and I found myself giggling at overheard conversations while Tube travelling back and forth and around and around. One such quip that I clearly recall, didn't actually happen on the Tube, but it was due to an Underground incident that happened at Knightsbridge station. I had just left Harrods where I was told you could find anything. I was missing tacos and needed Masa flour. Upon leaving Harrods with my bag of flour in hand, I headed for the Underground, and, to my amazement, the doors were closed – a suicide, a rather unfortunate but common occurrence. Homeward bound, I bounced onto the back of the bus, mood becoming more macabre as I imagined the mayhem, and having thoughts such as, what if I had left Harrods just a bit earlier, when a lanky East Ender boarded the train and said, 'Emagine doin' yourself in on payday.'

Other than needing to avoid Tube employees, photographing the Underground had several technical disadvantages such as low light and crowds. Shooting this space required that I push the speed of the film, Kodak TriX and Ilford HP5, to allow for the low light – another reason for shooting the architecture versus people. All subterranean shots, therefore, were taken at 800 ASA, rather than 400 ASA, allowing me to shoot at a higher shutter speed. Pushing film, i.e. 400 to 800 ASA, results in grainier pictures, an unavoidable necessity. On top of that, the lenses I used were slow lenses, 20mm and 28mm, meaning that less light enters the camera. Despite this, I often found myself shooting at speeds as low as a quarter of a second. At speeds below one-sixtieth of a second, a monopod or tripod is recommended in order get sharp pictures – dangerous to use in crowds, extremely time-consuming, and awkward if needing to leave the area quickly. So I stood planted firmly to the earth, elbows tucked tightly to my diaphragm, and held my breath, waiting for the just the right moment when, for example, all people had vacated the area or when a commuter

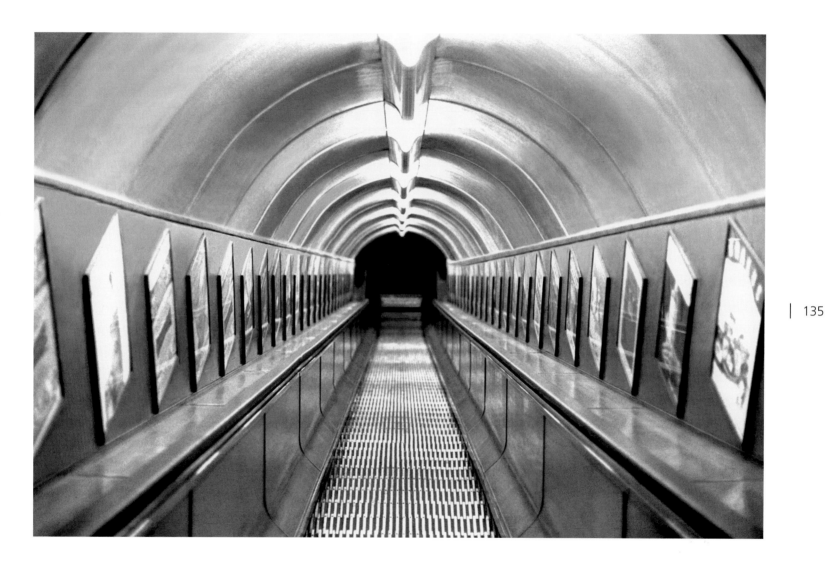

London Underground – architecture, design and history

hit the right spot. I had a talent for this and was able to get relatively clear shots. All photographers know this, but as film cameras are fading away, and digital cameras can alleviate many of these problems, I thought it informative to explain my process.

My other challenge was one of patience, as I more often than not wanted empty stations, with some significant exceptions. Indeed, the only negative critiques I have received regarding this collection is due to the absence of people: these few cannot see the trees through the forest.

With regard to film stock, I started shooting the London Underground using TriX, but I shifted to Ilford HP5. I found this film less grainy and it has a warmer tone than TriX. Recall, this was back in the 1970s. As I was initially drawn to the beauty of the wooden escalators, Ilford lent a soft warm quality that made the wooden stations more sensual.

I had to leave England prematurely, at least as far as I was concerned. My mother was seriously ill, my marriage was ending, and I had two beautiful dogs at home pining my absence as much as I missed them. I didn't want to leave. I loved living in England, and my work wasn't done. But home I went.

Needing to make money, I was hired by an old friend and a great commercial photographer, Bruno Schrek (translation: brown terror), as his number one assistant. Generously sharing his knowledge and secrets with me, I learned the studio. Setting up my own studio, after Bruno left to make millions in New York, I shot fledgling actors, musicians and entertainers. I attempted to market my London Underground series, but the time wasn't right so I closeted it and there it stayed until 2009.

Though I loved the darkroom experience, I disliked pouring chemicals down the drain, wasting precious water and paper. For decades, I waited for advanced film technology to emerge so I could bring this series back to life. I had never seen

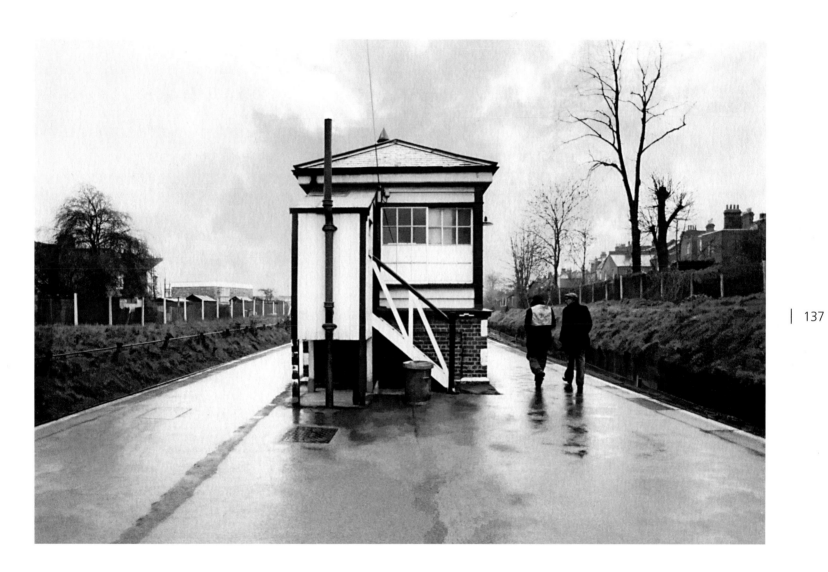

137

two-thirds of this collection in print until 2009. With the advent of film scanners, software and high quality pigment printers, I returned to this series that lay hidden to all, and how sad it would have been if this beautiful and historically significant collection had disappeared. The only disadvantage to digitising the negs is that I lost the warmth associated with using Ilford film. I chose to keep these strictly black and white rather than attempting to mimic the tone of the film.

I have always considered photography an art form. Though much of this series may be regarded as pure documentation of the London Underground, it was taken with an artist's eye – carefully and thoughtfully shot. Consideration of form, design, balance and when to include people are decisions an artist makes. More than architecture and design, this collection is a metaphor that speaks to our separate, and, perhaps, our lonely existence, among the multitudes, and hence, the people in these shots are primarily by themselves: they come they go, temporarily filling a space, rarely glancing at one another, reading or staring off into space or at maps and posters – they are, for the most part, in their own worlds. The more architectural shots, void of people, speak of this as well. But, know this too, it is when stations are empty of people that the history of the place comes alive. For without the bustle of people, one can feel the energy of by gone days – the blitz raging overhead, the architects and designers' choices, the souls of plague victims unearthed in the building of the London Underground, the millions of people who have travelled through this miraculous labyrinth; all of this is there. The debate as to whether or not photography belongs in the fine art realm is mostly over. This collection exemplifies how documentation as an art form can blend with an eye towards art to create something beautiful and profound.

Thank you Michelle Tilling and her colleagues at The History Press, who saw the possibility of this wonderful book.

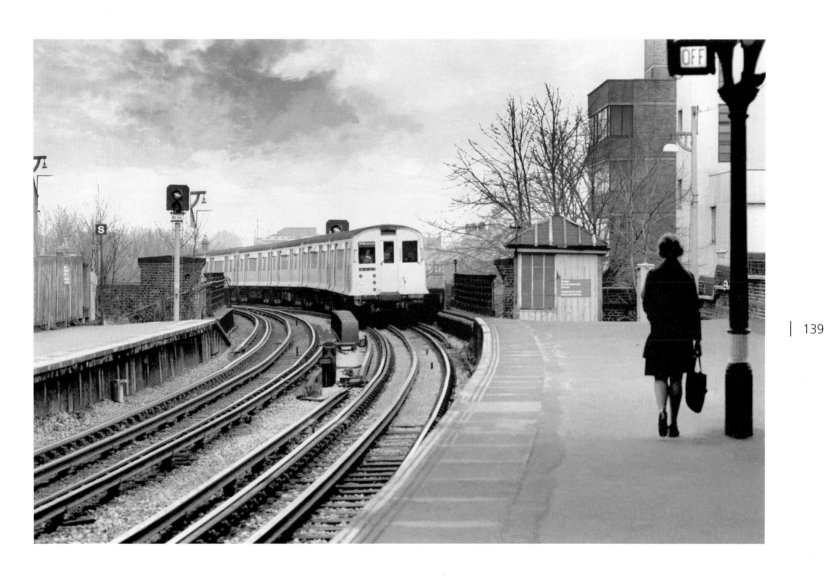

139

Thanks go to another good friend Marilyn Phillips whose comments, suggestions, fresh eye and artistic talent were spot on when it came to unscrambling my brain and arranging the order of the images.

Finally, thanks too, to a dear friend who has helped me throughout the years, Pam Baugh. Your help has been instrumental in my taking the next step and the next and the next . . . I cannot thank you enough for your friendship and support.

Jane Magarigal, 2011